W9-CHS-310

IMAGES
of America

FEDERAL HILL

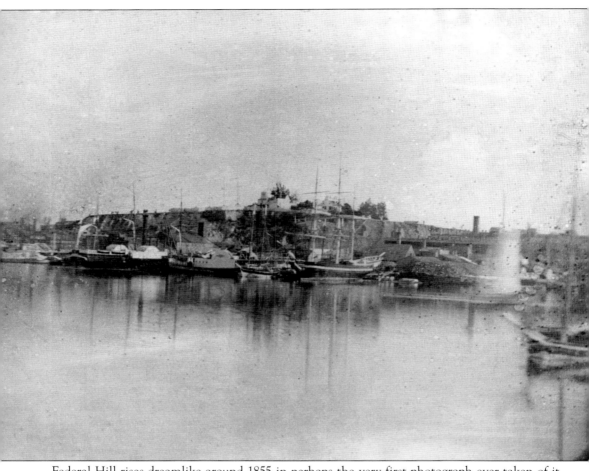

Federal Hill rises dreamlike around 1855 in perhaps the very first photograph ever taken of it. The observatory tower and flagstaffs are visible on the hill, as is the home of Capt. David Porter Sr., who built and worked in the observatory, alerting merchants of approaching ships. Note the natural, rough red-clay base of the hill, before it became smoothed and graded. (Courtesy of Enoch Pratt Free Library, Maryland's State Library Resource Center, Baltimore, Maryland.)

ON THE COVER: A 1940s photograph shows Charles Street, looking south from Hamburg Street. Charles Street is not only at the heart of Federal Hill's business district, but it is also one of the oldest and most vital streets in Baltimore. The very first home built in the city was erected less than a mile north of this location, near the corners of Charles and Lombard Streets. (Courtesy of Baltimore Museum of Industry.)

IMAGES
of America

FEDERAL HILL

William Clark and Maria Sosa

ARCADIA
PUBLISHING

Copyright © 2011 by William Clark and Maria Sosa
ISBN 978-0-7385-9206-0

Published by Arcadia Publishing
Charleston, South Carolina

Printed in the United States of America

Library of Congress Control Number: 2011932478

For all general information, please contact Arcadia Publishing:
Telephone 843-853-2070
Fax 843-853-0044
E-mail sales@arcadiapublishing.com
For customer service and orders:
Toll-Free 1-888-313-2665

Visit us on the Internet at www.arcadiapublishing.com

*This book is dedicated to all those who have ever lived,
worked, or merely had a good time in Federal Hill.*

CONTENTS

ACKNOWLEDGMENTS

We have met so many fine people while writing this book. Number one is our acquisitions editor, Elizabeth Bray, who has been so patient and so helpful. No matter how stressed she may have been, she always answered the phone with a smile in her voice—even her e-mails had a smile—and no matter what she may have been doing, she acted as if she had all the time in the world to talk. We were lucky to have shared this experience with her.

Then there were our neighbors who took the time to share their memories and photographs or merely pass the word that we were doing this book. We would like to thank everyone at the Federal Hill South Neighborhood Association, Federal Hill Main Street, Yale Klein, Ron and Mary Zimmerman, Ellen van Karajan, Larry Kamanitz, Hank Shofer, Marty McGihon, Jacque Kelly, Jim Sizemore, and the Reverend Patrick M. Carrion. We must also thank Jeff Korman and all of the librarians in the Maryland Room of Baltimore's Enoch Pratt Free Library as well as those at the library in the Maryland Historical Society and the University of Maryland Libraries' Maryland Room. There were many others who helped, and we thank you all.

Three people deserve special mention for their invaluable contributions: first, there is Catherine Scott of the Baltimore Museum of Industry, who went above and beyond in her kindness and interest in this project; next are Jules Morstein Jr. and his associates at Morstein Jewelers, who were fonts of information on the neighborhood and shared many wonderful photographs from their scrapbooks; and last, but not least, is Jay D. Smith of the Hearst Corporation, who granted permission to use photographs from the old *Baltimore News American*.

The images in this volume appear courtesy of the Special Collections, University of Maryland Libraries (UMDL); Baltimore Museum of Industry (BMI); Enoch Pratt Free Library, Maryland's State Library Resource Center, Baltimore, Maryland (EPFL); Maryland Historical Society (MHS); Library of Congress (LOC); Jules Morstein Jr. (JMJR); Hank Shofer (HS); Holy Cross Church (HCC); American Visionary Museum (AVAM); and the authors (AU).

INTRODUCTION

When Baltimore locals hear the words "Federal Hill," many images come to mind. First, they may think of Federal Hill Park and its grand skyline view, an oasis in a tough but beautiful city. Next, they may think of the Federal Hill neighborhood—the business district with its shops, restaurants, and the Cross Street Market; the historic districts and their stately streets lined with 19th-century row houses. Those who actually live in the Federal Hill zone will also think of the people in their community: the old-timers who grew up there and never left, the urban professionals whose home renovations have changed the look and feel of the neighborhood, and the students and young people who flock to the bars and restaurants, spilling out into the streets, making nighttime loud and electric.

Of course, Federal Hill is all of these things and more. In an old city, it is among the oldest neighborhoods. For years, the area was simply known as South Baltimore. Yet, from its earliest days, it encompassed a surprising diversity of people, both ethnically and economically. There were shipbuilders and those who actually built the ships, freed slaves and former slaveholders, titans of industry and those who made their factories hum, influential politicians and those who voted them in or out, the big guys and the little guys, and the mighty and the meek, many living on the same block, on wide avenues and narrow alley streets.

The first person to write about Federal Hill was an Englishman, Capt. John Smith, most famous for his role as an explorer who helped found and govern Jamestown, Virginia, the first permanent English settlement in the New World. In 1608, some six months after he claimed that his life was spared by Pocahontas (daughter of the Powhatan chief—named Powhatan—who had sentenced him to death after his capture), Captain Smith began to explore the Chesapeake Bay. Accompanied by 14 men, he covered more than 3,000 miles in his first 19-day journey.

Smith was impressed with what he saw. In his journal he wrote, "Within is a country that may have the prerogative over the most pleasant places known, for large and pleasant navigable rivers, heaven and earth never agreed better to frame a place for man's habitation." He also noted that in the Chesapeake's waters, the oysters "lay thick as stones." Eventually, he came across the bay's first navigable river, which he called "Bolus;" it is now known as the Patapsco River. Near the end of his trip down the Patapsco, Smith wrote of "a great red bank of clay flanking a natural harbour basin." The basin is now Baltimore's Inner Harbor. The great red bank of clay became known as Federal Hill.

It got the name after Baltimore's citizens clambered up the hill to celebrate the ratification of the federal constitution by Maryland's General Assembly on December 22, 1788. If the day was cold, and it probably was, it did not seem to put a crimp into the day's revelry. Huge quantities of food and alcohol were consumed by some 4,000 celebrants in a daylong festivity that rambled late into the night. Fireworks lit up the sky, and a large bonfire offered amusement and warmth. It was a feast not soon to be forgotten. And to honor it, people started referring to the great red-clay bank as Federal Hill.

A community began to sprout up around Federal Hill. By 1860, several grand churches had been erected, schools built, and businesses established, and brand-new row houses lined dirt and cobblestone streets. On February 23, 1861, president-elect Abraham Lincoln passed through Baltimore on his way to his inauguration in Washington, DC. Rumors of an assassination plot stirred, and it was believed that Lincoln would be shot while transferring from the President Street Station to the Camden Street Station near Federal Hill. The plot, if it existed, was foiled, and newspapers had great fun picturing Lincoln disguised in a Scottish tam, ducking assassins between train rides in Baltimore.

But it was no laughing matter when the first shots of the Civil War were fired at Fort Sumter less than two months later. A week after that battle, Union troops were making the same journey President Lincoln had made, transferring from the President Street train station to the train at Camden Yards. Along the way, they were intercepted by a mob of Southern sympathizers, and a riot broke out. Four soldiers and 12 civilians were killed. To keep the city from becoming a hotbed of Confederate conspiracy, Gen. Benjamin Franklin Butler marched a regiment of troops onto Federal Hill on the night of May 13, 1861, during a driving rainstorm. A permanent fort was eventually built, and troops stayed on to occupy Federal Hill through the end of the war.

After the Civil War, Federal Hill grew as a prime location for shipyards and canning factories. The red clay from the hill was mined to make bricks, and sand was gathered to make glass. The neighborhood became home to several large chemical factories and fertilizer works. In 1921, McCormick and Company, a leading spice manufacturer, built a factory that spread the scents of cinnamon, nutmeg, and other spices through the air. Well into the first half of the 20th century, there were barrel-makers and breweries, a thriving market on Cross Street, shops, restaurants, and department stores.

And then . . . much of it shut down. The shipyards, the glassworks, and even the spice factory moved away. For the first time, many neighborhood residents had to find work elsewhere. Merchants who serviced those workers saw their businesses decline. In the 1960s, the city government even threatened to run a major highway through the neighborhood, paving over Federal Hill Park itself. But the residents fought back. And in the end, Federal Hill won.

So, beyond just being a park, a neighborhood, or a community of people, Federal Hill is also a survivor. Today, some say it is better than ever, while others swear it will never again be as good as it was. Yet it thrives and feels unified, even as the blue-collar fist once known simply as "South Baltimore" has been divided—at least by name—into the delicate digits of Federal Hill, Federal Hill South, Sharp Leadenhall, and Otterbein. Separately, each neighborhood has been designated as a historic district, but their stories, like their streets, still intersect. These pages attempt to tell many of those stories.

One

THE GREAT RED-CLAY BANK

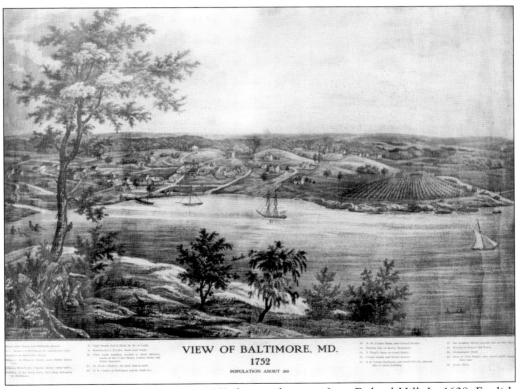

VIEW OF BALTIMORE, MD.
1752
POPULATION ABOUT 300

This idyllic drawing of Baltimore in 1752 depicts the view from Federal Hill. In 1608, English explorer Capt. John Smith sailed the Chesapeake Bay into the Patapsco River, where he wrote of a "great red bank of clay flanking a natural harbour basin." For more than a century, the great red bank would be known as "John Smith's Hill." (Courtesy of BMI.)

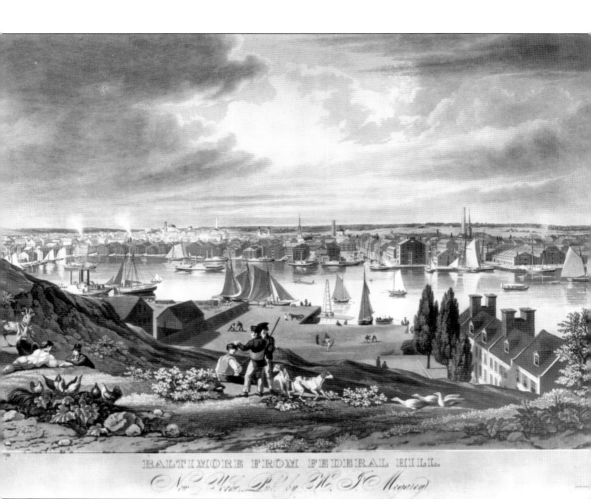

BALTIMORE FROM FEDERAL HILL.

By 1830, the date of this painting, Baltimore had grown to become a thriving port city, and bucolic John Smith's Hill had a new name. On December 22, 1788, Baltimore celebrated the ratification of the US Constitution by the Maryland General Assembly in Annapolis. A joyous procession rambled through downtown Baltimore, with a 15-foot replica of a ship, dubbed the *Federalist*, dragged along the streets on wheels. The parade ended at John Smith's Hill, where some 4,000 revelers feasted on 1,000 pounds of beef, 500 pounds of ham, 240 barrels of hard cider, more than 15 barrels of beer, and nearly 10 gallons of peach brandy. A giant bonfire lit up the night, along with a colorful fireworks display. Around midnight, the *Federalist*, which had been docked at the foot of the hill, was commandeered by several celebrants and sailed successfully to Annapolis. It was later presented as a gift to Gen. George Washington. Following this most memorable and raucous festivity, citizens began referring to John Smith's Hill as Federal Hill. (Courtesy of the BMI.)

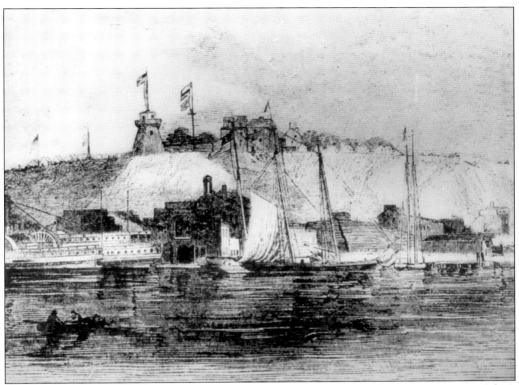

Federal Hill's next wild celebration marked the official opening of the observatory tower on July 4, 1797. Capt. David Porter Sr. sold merchants on the idea of the observatory. Using a telescope, he scanned the horizon for approaching ships. Once he identified them, he hoisted a flag matching the flag on the vessel to alert merchants in the harbor that their ship was indeed coming in. (Courtesy of EPFL.)

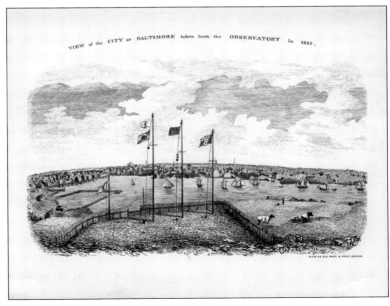

VIEW of the CITY of BALTIMORE taken from the OBSERVATORY in 1822.

Here is another view of the growing city of Baltimore, this one from the perspective of the observatory tower in 1822. The flagstaff in the foreground is where the flags of approaching ships were flown. Merchants designed their own flags and kept a close watch on the hill for the signal of their ship's arrival. (Courtesy of BMI.)

11

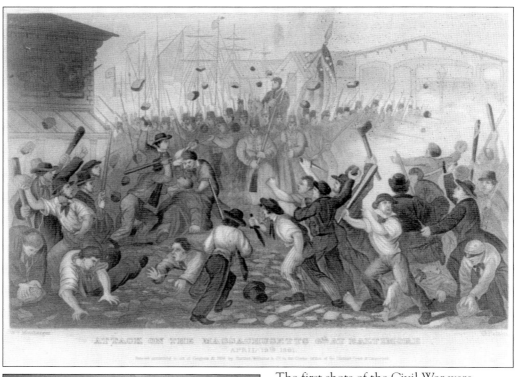

ATTACK ON THE MASSACHUSETTS 6TH AT BALTIMORE
APRIL 19TH 1861

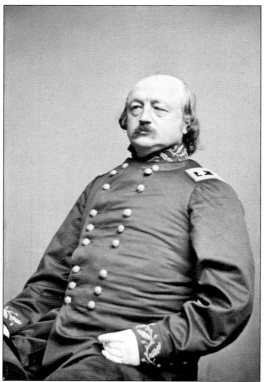

The first shots of the Civil War were fired at Fort Sumter, South Carolina. One week later, on April 19, 1861, Baltimore was drawn into the fray. As Union troops marched down Pratt Street to the Camden Yards train station, they were confronted by an angry mob of Confederate sympathizers. Four soldiers and a dozen civilians were killed in the daylong riot. (Courtesy of LOC.)

Baltimore fell under the jurisdiction of Gen. Benjamin Franklin Butler, who decided Union troops were needed to occupy the city to discourage the secessionist movement. He knew his superiors would reject his radical plan, so, without asking permission, General Butler boldly marched his troops to Federal Hill and set up camp on the night of May 13, 1861. (Courtesy of LOC.)

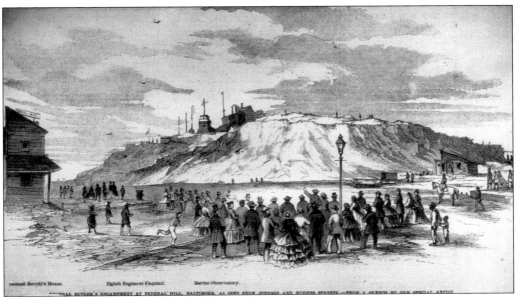

General Butler's occupation of Federal Hill came under the cover of night and a driving rainstorm. The next morning, most locals were stunned by the sight of tents and troops overlooking Baltimore. This picture shows curious residents staring up at the occupied hill from the northwest corner of Hughes and Johnson Streets (roughly where Key Highway and Battery Street meet today). (Courtesy of EPFL.)

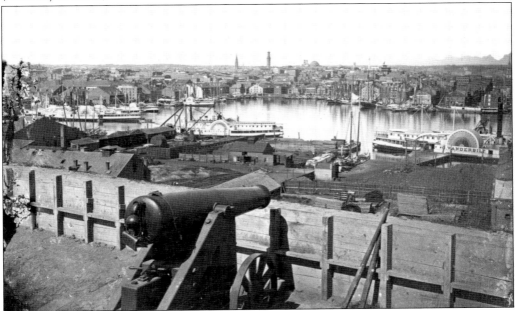

The Union army quickly set up tents and canons. This one is pointed directly at downtown Baltimore. In fact, the fort's largest cannon was aimed specifically at the Maryland Club on Mount Vernon's Monument Square, a known den of radicals siding with the South. General Butler ordered his troops to open fire on Monument Square if anything were to happen to him. (Courtesy of EPFL.)

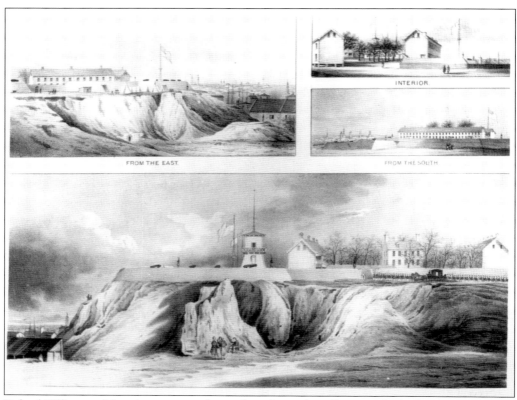

FROM THE EAST.

INTERIOR

FROM THE SOUTH.

Federal Hill's peaceful setting was turned into a base for war literally overnight. By late summer, troops began working around the clock to construct a permanent facility. The illustration above details several views of the fort. The barracks could hold 1,000 soldiers, and an 80-foot well was dug to provide freshwater. Tunnels were also dug into the hill by Union occupiers to store guns and ammunition. One tunnel was rumored to be an escape route that ran all the way to Camden Station, nearly a mile away. The painting below shows Fort Federal Hill as it appeared on July 4, 1864, as locals entered for a staged celebration. Note that the observatory tower still stands near the fort's northwest corner, though no record reveals if signals to merchants continued during the war. (Courtesy of EPFL.)

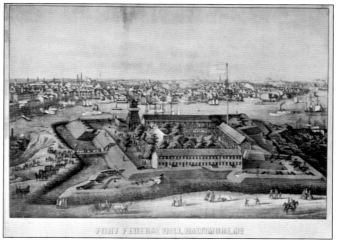

FORT FEDERAL HILL, BALTIMORE, MD

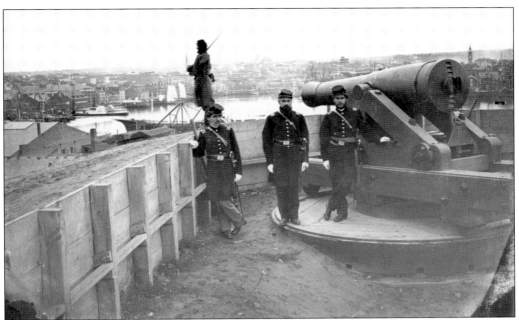

In the image above, Union soldiers pose near a cannon aimed at Fell's Point on the fort's northeast corner. In the photograph below, soldiers strike their best jaunty stances on the northwest corner. During Federal Hill's occupation, several different regiments took over duty there, including the 6th Massachusetts Regiment, the colorfully dressed 5th Regiment New York State Zouaves (or "Zou Zous," as they were called by the locals), the 7th New York Militia, and the 131st Regiment National Guard. With no actual fighting to do, the soldiers spent most of their time drilling and parading, a popular entertainment for the city's residents. Following the capture of Richmond on April 3, 1865, a 100-gun salute was fired from Fort Federal Hill. Finally, on New Year's Day 1866, the fort was officially shut down. (Both, courtesy of EPFL.)

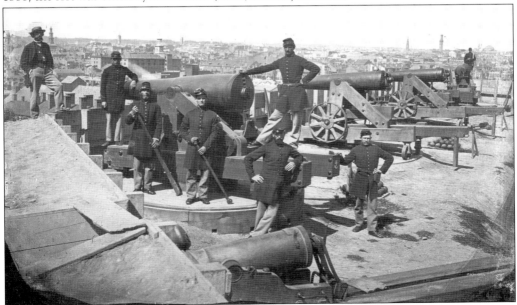

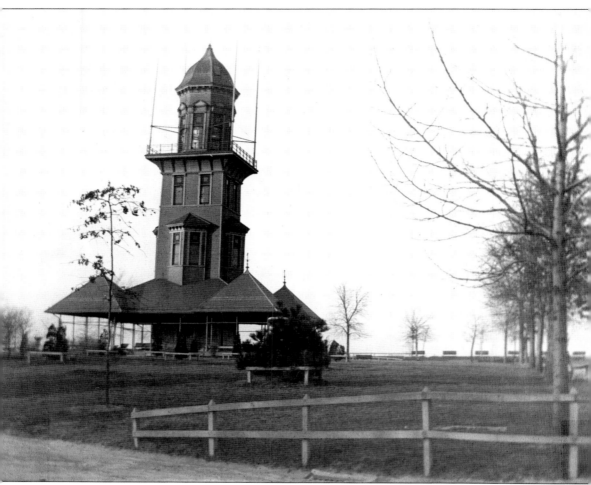

In 1880, Baltimore officially made Federal Hill a public park. Seven years later, the park commission built a new observatory—a Victorian structure that was much more ornate but much less practical than the old one. The building swayed and groaned in heavy storms. Strong winds blew out windows on a regular basis. After one year, the tower was actually leaning about half a foot. But the ice-cream stand on the first floor continued to serve frozen treats, and paying customers climbed the stairs to the top to peer out at the amazing view. In 1899, the city fathers finally devised a telephone system, which rendered the tower's system of posting flags obsolete. Still, it stood leaning and groaning a few more years until it faced one final tempest. On July 20, 1902, a raging wind blew the tower over. It crashed violently to the ground and was permanently destroyed. (Courtesy of the EPFL.)

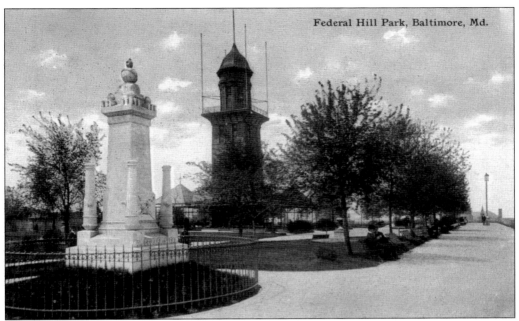

Federal Hill Park, Baltimore, Md.

Here are two picture-postcard views of Federal Hill from around the turn of the 20th century. Above is a view of the Armistead Monument with the still-standing observatory behind. The monument was erected on the park's northeast corner in 1882. It is dedicated to Lt. Col. George Armistead, the commander of nearby Fort McHenry in Locust Point during a 25-hour battle against the British fleet on September 13–14, 1814. His hard-fought victory inspired Francis Scott Key's writing of the "Star-Spangled Banner." The postcard below shows the southwest corner of the park, looking across to the city skyline. The base of the tower still stands to the right, though the tower itself appears to have already fallen. (Above, courtesy of UMDL; below, courtesy of EPFL.)

Federal Hill Park. BALTIMORE, MD.

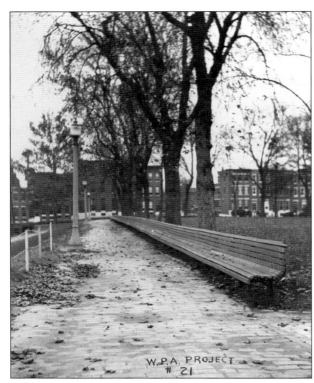

This photograph, taken by the Works Progress Administration in the mid-1930s, shows the old granite block sidewalks that ran around the park. Notice the benches strung together in one long, continuous row. Stately row houses along Warren Avenue face the park. These homes, still standing today, were built in 1885, following the demolition of Fort Federal Hill. (Courtesy of EPFL.)

Looking north at the park's inner walkway, this WPA photograph shows the path that now circles the play area in Federal Hill Park. One of the tasks for WPA Project No. 21 was to pave this gravel path and replace the old granite walks with concrete. The base of the old observatory still stands at left. (Courtesy of EPFL.)

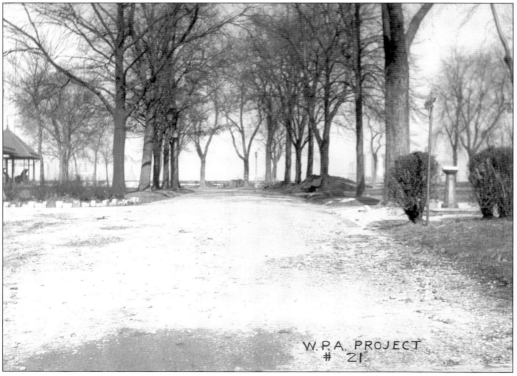

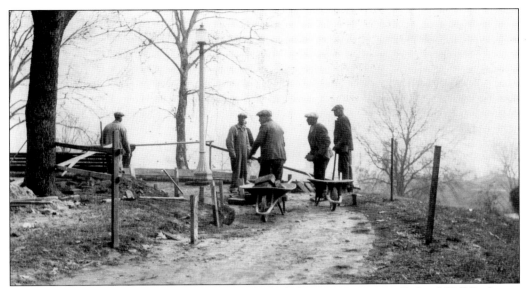

The Works Progress Administration targeted needed improvements to Federal Hill Park as a project to get the unemployed back to work and kick-start the Depression-era economy. Sixty WPA employees were assigned to the project. Here, several workers remove the old granite bricks from the outer walkway on the northeast corner of the park. (Courtesy of UMDL.)

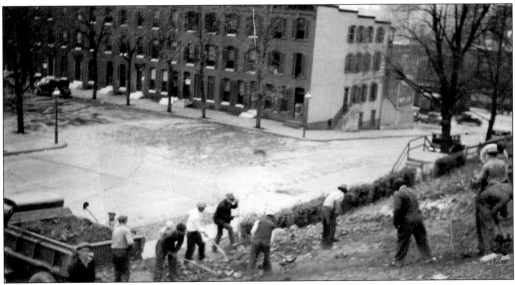

WPA workers put their backs into smoothing out the western slope of Federal Hill. Constructing the park's long stairway, at right, was also a part of Project 21. Beyond the arduous activity in the park, the distinguished row houses of Montgomery Street stand tall as cars bustle along Key Highway. (Courtesy of UMDL.)

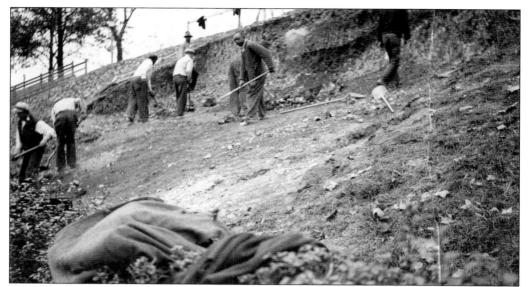

From this angle, looking up at the western slope of the hill, one can see the difficult task the WPA workers were up against. The hill's red-clay base was sloped, but naturally rutted, and making it smooth using shovels and manpower was no easy chore. WPA workers labored 40 hours a week and were paid an average of $41.57 a month. (Courtesy of UMDL.)

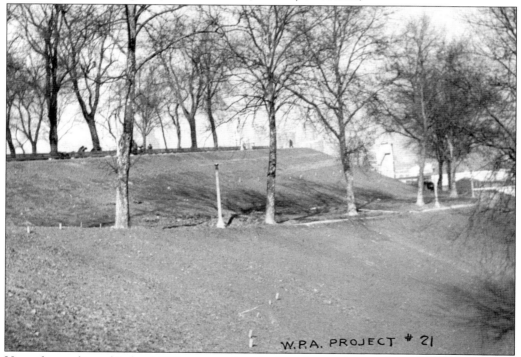

Here, the grading of Federal Hill's eastern slope looks to be nearly complete. The park's base has been smoothed out, but the upper and lower walkways that rim the park do not appear to be paved yet. Earlier drawings indicate that this side of the hill was probably the most uneven slope and must have been very difficult to grade. (Courtesy of EPFL.)

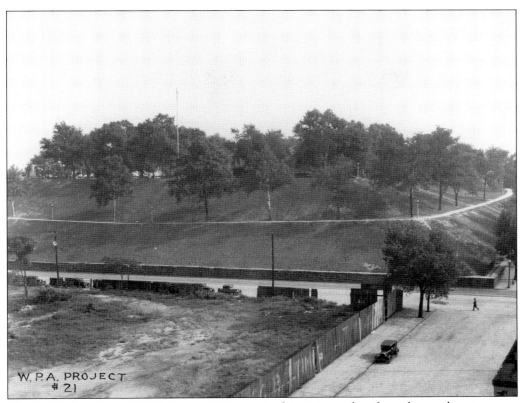

The finished product of WPA Project 21 is seen in this picture taken from the northwest corner, near what is now Key Highway and Battery Street. Years before, tunnels had been dug below the hill to excavate sand and clay. Breweries also used these tunnels to store kegs of beer. They later became a dangerous but irresistible subterranean playground for the neighborhood kids. (Courtesy of EPFL.)

As a result of the tunnels, cave-ins on Federal Hill became relatively routine. This one, after a heavy snow in February 1972, caused part of the sidewalk to break off and a section of the hill to dip five feet. A city geologist speculated it was caused by the collapse of an old brick-lined tunnel dug by Union soldiers to transport ammunition. (Courtesy of UMDL.)

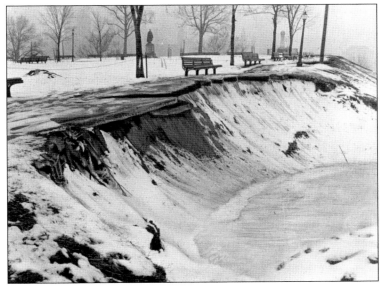

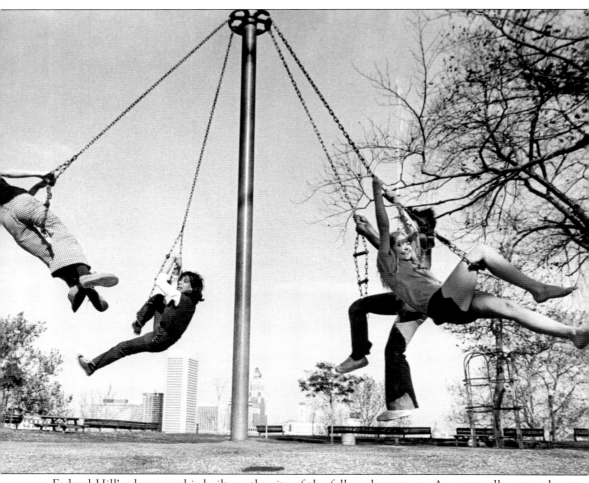

Federal Hill's playground is built on the site of the fallen observatory. An unusually warm day in November 1974 brings students from nearby Southern High School out for a swing. But the playground equipment is only one of the ways kids have discovered to have fun in the park. For years, they came to play hide-and-seek or treasure hunt among the hill's underground caves. And in winter, old aluminum awnings or strips of plastic mats made impromptu sleds to whiz down the hill's steep sides. Today, a basketball court sits at the bottom of the northeast corner, often attracting hoops-lovers looking for a pickup game. And of course, the hill's one remaining cannon is always great to help spark the imagination. In the background of this photograph, the recently built United States Fidelity and Guaranty Company building looms. Completed in 1970, it remains the tallest building in Maryland at 39 stories. (Courtesy of UMDL.)

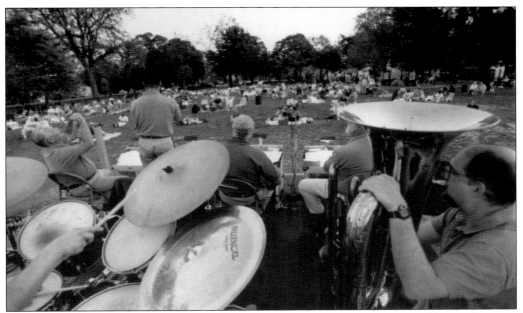

This lively c. 1990 spring concert in the park was a thank-you from Federal Hill's merchants to the community. The park has served as a showcase for many different types of entertainment, including plays and a popular summer film series sponsored by the American Visionary Museum. It is also one of the prime spots to view the city's spectacular Fourth of July and New Year's Eve fireworks displays. (Courtesy of JMJR.)

Federal Hill maintains its long history of political gatherings and celebrations. On October 21, 2010—just days before the November election—Baltimore mayor Stephanie Rawlings-Blake addresses the crowd at a Democratic Party rally. Behind her are several members of the audience who were chosen to share the stage with the speakers, including former president Bill Clinton and Maryland governor Martin O'Malley, among others. (Courtesy of AU.)

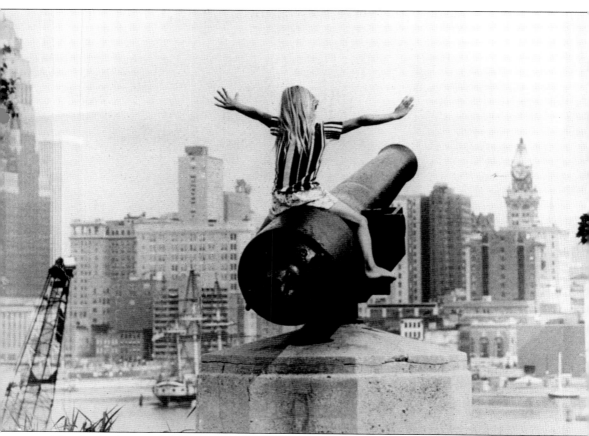

This lively photo, titled *That Happy Feeling*, was snapped in 1974. It won first place in the features category of a photo contest in the *Baltimore News American*. Few images better capture the joy of city living or display the love most residents of Federal Hill have for their park. It is *the* spot for a breathtaking view of the city skyline, provides a favorite backdrop for local newscasts, and made a dramatic impression in television programs, including *Homicide: Life on the Street* and *The Wire*. Dog-walkers and exercise enthusiasts gather here in the morning, children rule the playground during the day, and its benches beckon for couples taking a romantic stroll in the evening. For more than 200 years, the park has served as the soul of a community, and it remains a very treasured jewel in the city of Baltimore. (Courtesy of UMDL.)

Two

STREET SCENES

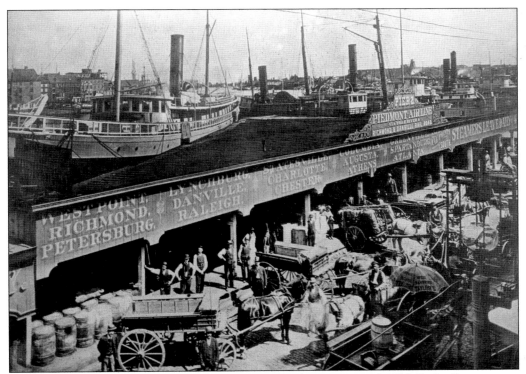

This photograph of the Light Street wharf probably dates to around 1885. Light Street serves as the main gateway into Federal Hill. Note the original observatory tower on Federal Hill in the upper right, above the Pier 2 sign. Merchants still depended on the tower to alert them of approaching ships. These wooden stalls on the wharf burned down in the great fire of 1904. (Courtesy of EPFL.)

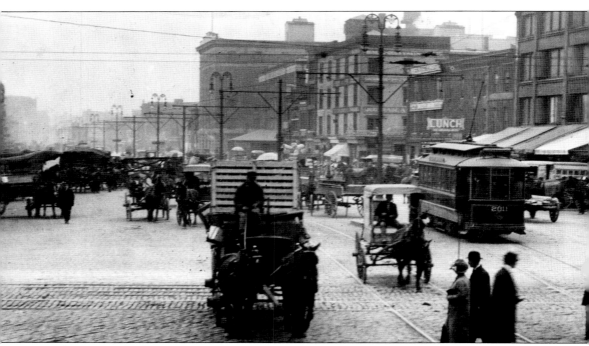

This view is looking south on Light Street from Pratt Street on a typical bustling weekday in 1914. One can easily see why this corner earned its reputation as the busiest in Baltimore. The intersection frames the northwest boundary of the Patapsco River, heart of the Inner Harbor. Ships from all over the Chesapeake and Atlantic seaboard journeyed here, loaded with fruits, vegetables, fresh seafood, and other goods. After crews unloaded their cargo at the wharves, the produce and materials were packed onto horse-drawn carts to be distributed to markets and factories throughout the city and beyond. This was the hub of all of that action. Pedestrians seem to be taking their lives in their hands crossing in front of the chaos. The two policemen at lower right appear oblivious to it all. Note the streetcar at right just above them. These cars took riders right up Light Street, into the business district of Federal Hill. (Courtesy of UMDL.)

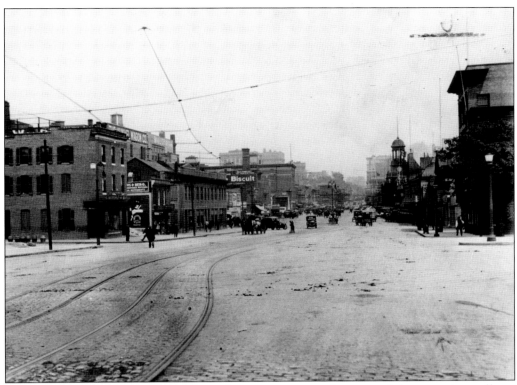

This reverse angle of the photograph on the previous page, taken around the same time, offers a view of Light Street looking north from Hill Street. The tracks from the streetcar line continue into the heart of the Federal Hill business district. The iconic clock tower of the Baltimore Packet Company, better known as the Old Bay Line, is on the right. (Courtesy of UMDL.)

Another view of Light Street looks north near Conway, around 1930. The busy street is still covered by cobblestones, which must have made it a rough ride for the automobiles that were now common. The wharves, at right, not only brought in everything from oysters to bananas, but steamships took passengers on excursions as far as Florida, with connections to Havana, Cuba. (Courtesy of BMI.)

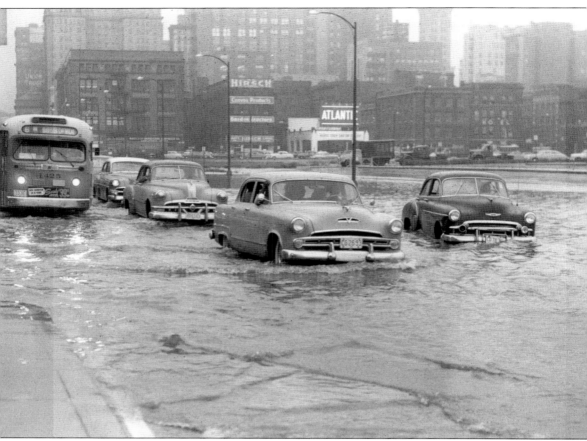

By 1950, the wooden wharves had become old, broken-down relics. The ships were no longer unloading their bountiful cargoes, and the excursion cruises had dwindled. Baltimore mayor Thomas J. D'Alesandro Jr. ordered the obsolete eyesores torn down. But, with the wharves removed, the Patapsco River would flood its banks during driving rainstorms, creating a rough commute for those trying to get to or from their homes in Federal Hill. This rainy day in 1955 resulted in a particularly miserable rush hour. But it could have been a lot worse. Even when the wharves were still standing, hurricanes sometimes lashed the Patapsco, causing as much as six feet of river water to rise over the banks onto Light Street, requiring some products to be delivered by boat. In 1970, the city raised the level of the sidewalks along the river to prevent scenes like this one. (Courtesy of EPFL.)

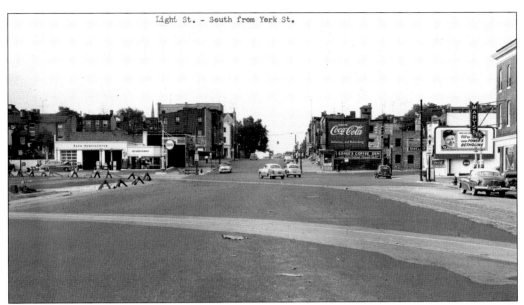

The intersection of Light Street and Key Highway is shown around 1954. Continuing straight on Light Street leads right into the Federal Hill business district. Going left down Key Highway leads to Federal Hill Park and the Bethlehem Steel Shipyard. The ad behind Mary's Bar features Bobo Newsom, who provided color commentary for the Baltimore Orioles baseball games on TV. The team had only recently arrived in town. (Courtesy of BMI.)

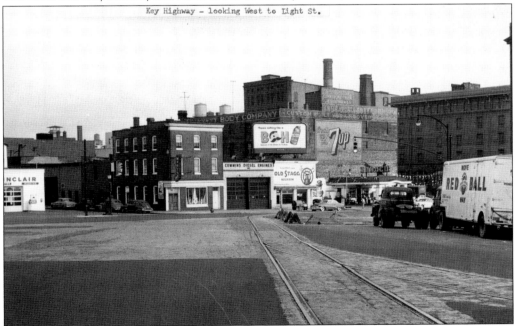

This is a reverse view of the picture above, coming down Key Highway toward Light Street. In 1976, the Maryland Science Center was built on the location behind the Red Ball moving van at right. In fact, none of the buildings in the foreground remain. Straight ahead, a billboard for National Bohemian beer, still a Baltimore favorite, features the iconic Mr. Boh. (Courtesy of BMI.)

Yet one more angle of the Key Highway and Light Street intersection shows the view from Hill Street looking north toward Key Highway. The warehouses that would soon be torn down still house the American Red Ball Transit Company and Fred Crebbins Inc., sellers of boat engines and equipment. These buildings stand on the current site of the Maryland Science Center. (Courtesy of BMI.)

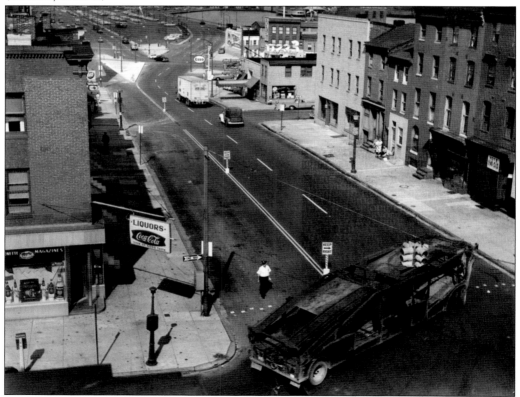

This view, from 1959, was taken from the top of the fire station on Montgomery Street, looking north on Light Street. A policeman has been sent to this intersection to help trucks maneuver the sharp turn. The "keep right" sign was repeatedly knocked over. (Courtesy of UMDL.)

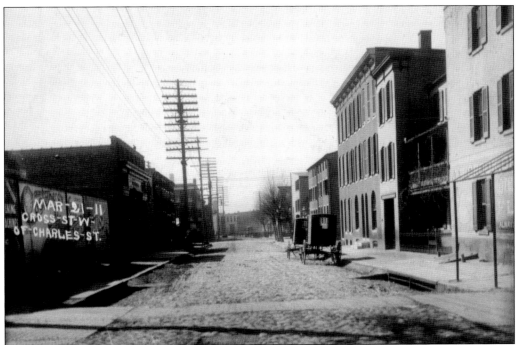

The photograph above, taken on March 21, 1911, looks west on Cross Street, next to the Cross Street Market. Note the livery stable by the two coaches. After hitching up his horse, a person could walk across the street to the Garden Theater, an early movie house. The theater later moved around the corner to Charles Street. The photograph below was taken the same day, just one block further down Cross Street, looking west past Hanover Street. It offers a very early look into the Sharp Leadenhall neighborhood, the oldest predominantly African American community in Baltimore. A colony of free African Americans had settled near here as early as 1790; even before the Civil War, the community had extended several blocks south to this location. (Both, courtesy of EPFL.)

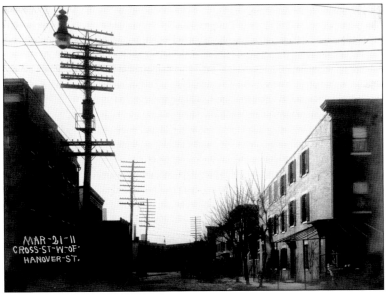

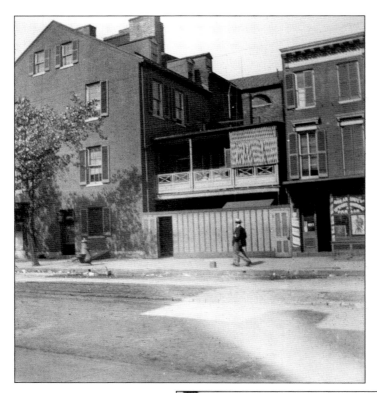

Around 1910, a well-dressed man, parcel under his arm and straw hat on his head, takes a stroll down Sharp Street, in what is now Sharp Leadenhall. It is possible that he has just come out of the Anne Arundel Up-To-Date Barbering Parlor, at right. The greeting on the barbershop's front door cheerfully announces "U Next." (Courtesy of EPFL.)

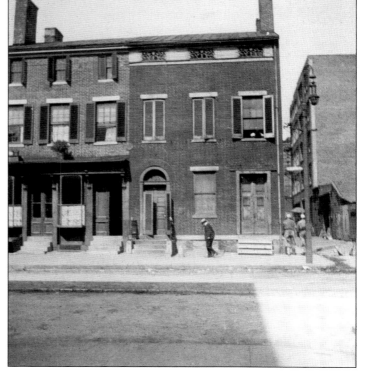

On Charles Street, just south of Lee Street, on a hot day in 1914, a man appears to wither in the heat, and a boy looks down from his second-story window. At right, two laborers wearing aprons approach a woman in the alley who holds an umbrella as shade. Notice the interesting scrollwork at the top of the building on the right. (Courtesy of EPFL.)

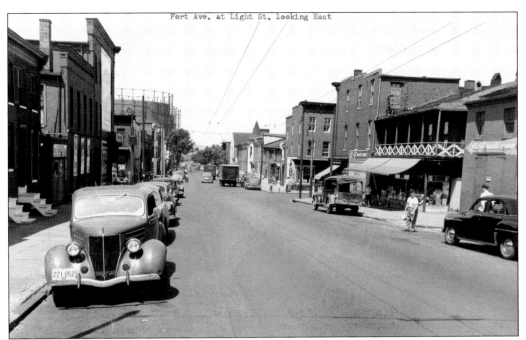

Here is the view looking west on Fort Street toward Light Street in the late 1940s. The L&F Men's Shop stands on the northeast corner, facing the Dixie Restaurant across the street. The New Coffee Cup Restaurant is on the southwest side of Fort Street. Most of these buildings remain, but the large gas storage tanks at left are long gone. (Courtesy of BMI.)

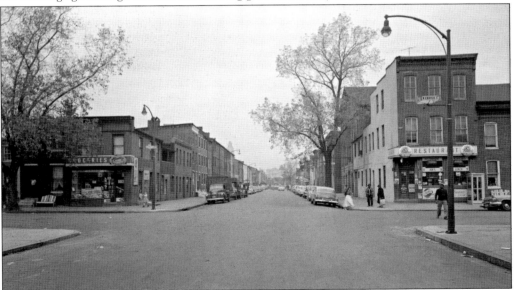

This is a view of Leadenhall Street looking north past Cross Street in the late 1950s. Joe's Restaurant on the right stands directly in front of the Leadenhall Baptist Church. Beyond that, Jack's Bar sits at the corner of Leadenhall and Hamburg Streets. The grocery store and most of the buildings on the left were demolished. With the creation of Solo Gibbs Park, Cross Street currently dead-ends at this intersection. (Courtesy of BMI.)

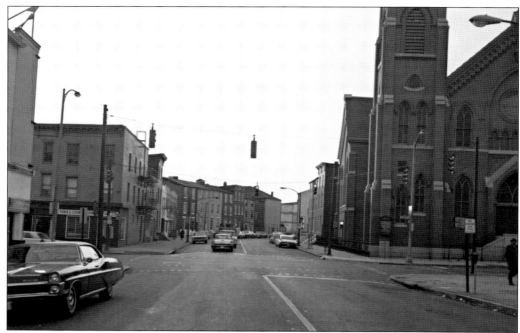

The photograph above looks west on Hamburg Street toward Hanover Street around 1965. The church at right is currently known as Sts. Stephen and James Evangelical Lutheran Church, built in 1850 and still in use. Straight ahead is the Sharp Leadenhall neighborhood. The photograph below shows the reverse angle, from Hamburg Street looking toward Hanover Street, with Charles Street beyond. Shofer's Furniture stands at left on the northwest corner of Charles and Hamburg Streets. A duckpin bowling alley occupied the second floor of the building across the street on the southwest corner. The structure housing the bar on the southeast corner of Hamburg and Hanover Streets has been demolished. (Both, courtesy of BMI.)

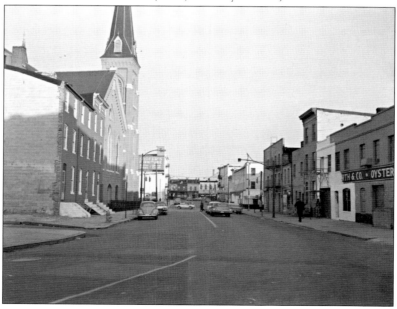

This late-1940s view shows Hanover Street looking north from Ostend Street. The spire of Sts. Stephen and James Evangelical Lutheran Church can be seen at left. Hanover Street was another route that took commuters in and out of downtown. At right, Smith's Groceries is ready for business at 1207 Hanover Street. It is currently a residence. (Courtesy of BMI.)

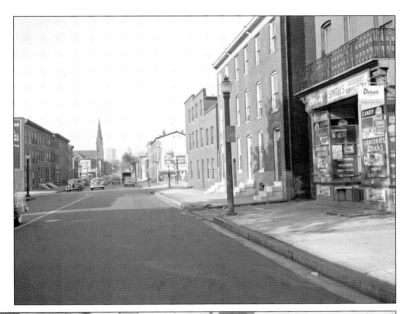

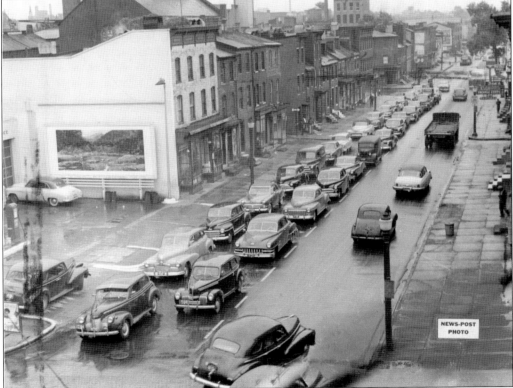

Further north on Hanover Street, a traffic jam stops cars in their tracks waiting for the light at Hill Street as they head downtown. This photograph, taken around 1952, shows a much busier-looking Hanover Street than drivers are currently used to. Today, this portion of the street has been narrowed, and traffic is routed only one way, south. (Courtesy UMDL.)

This is the 1100 block of Riverside Avenue in July 1975. These buildings on the east side of the street are all covered in Formstone, Baltimore's favorite form of faux masonry. Baltimorean Albert Knight patented Formstone in 1937, primarily as a way to beautify homes that had additions with unmatched siding. But in the 1950s, Baltimore residents began using it to cover the porous brick fronts of their row houses. Then, for unknown reasons, Formstone went from practical siding to status symbol, and solid walls of it lined city streets. By the 1980s, however, the beauties of Formstone had begun to fade, and a new generation of homeowners started stripping it off. The photograph below shows how the same section of Riverside Avenue looked in 2011. (Both, courtesy of UMDL.)

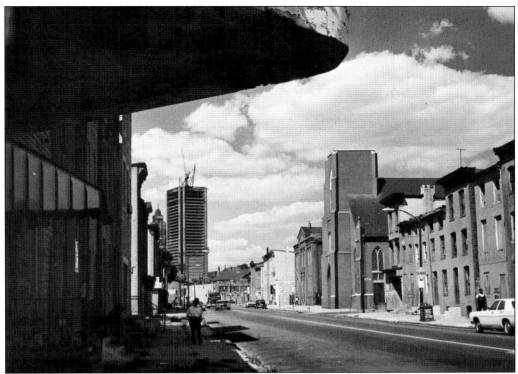

This c. 1972 photograph shows a bleak view of Sharp Street's 800 block. At this time, the block was the focus of a sweeping and controversial urban renewal program, and most of the buildings on the left were marked for demolition. The church at right was remodeled into apartments. In the distance, the still-under-construction United States Fidelity and Guaranty building looms. (Courtesy of UMDL.)

This photograph of Leadenhall Street looking south was taken in the fall of 1972. In the 1930s, zoning laws were changed to allow industrial buildings into the Sharp Leadenhall neighborhood. The gas-storage tanks and small factories show the unsightly result years later. The storage tanks have since been removed. (Courtesy of UMDL.)

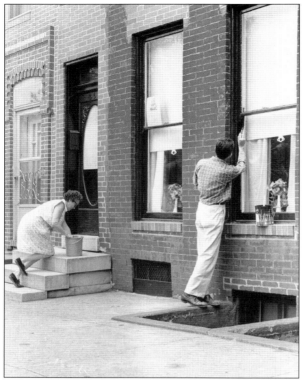

A couple works together to keep up appearances on their Montgomery Street home in 1967. As the man paints the trim around the windows, the woman engages in a cherished Baltimore tradition, scrubbing the marble front steps of her row house. Marble stairs were a source of pride in neighborhoods throughout the city, and giving them a good Saturday-morning scrubbing was a weekly ritual. (Courtesy of UMDL.)

This is the interior of a typical row house on Montgomery Street in 1973. High ceilings and narrow rooms are the norm downstairs. First-floor bathrooms are rare, even in remodeled homes. Upstairs, bedrooms were often created using a railroad design, without a hallway and requiring occupants to walk through one bedroom to get to another. (Courtesy of UMDL.)

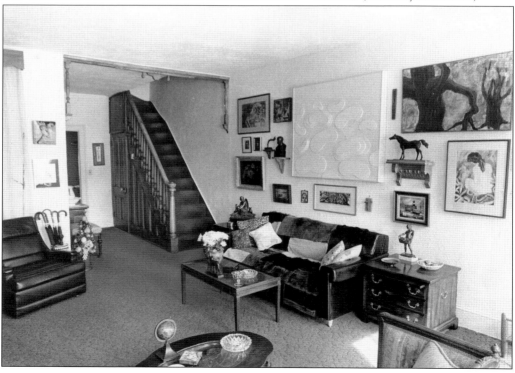

From his row house at 413 Warren Avenue, this man indulges in the time-honored Baltimore tradition of taking in the world from his front stoop. At the far eastern end of Warren Avenue, this address offers magnificent views of the park and the harbor. When this photograph was taken in 1973, the Bethlehem Steel Shipyard was still in operation. (Courtesy of UMDL.)

The homes on the 400 block of Warren Avenue, facing Federal Hill Park, were built in 1885. Nearly 100 years later, this row house at 401 Warren Avenue was reported to be the first home sold in the neighborhood to crack the $100,000 barrier. It has most recently sold for more than seven times that amount. (Courtesy of UMDL.)

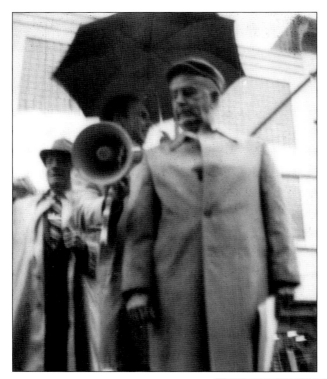

Politicians have often ventured to Federal Hill to raise their profile in South Baltimore. Left, William Donald Shaefer, one of Maryland's most iconic political figures, gets ready to address a crowd on Light Street in the late 1970s. Shaefer served four terms as mayor, from 1971 to 1987, his bold leadership leaving a large footprint on the entire city, including the Federal Hill area. Mayor Shaefer's sometimes controversial urban renewal programs led to a rejuvenation of many parts of the city, most notably Otterbein. He would go on to serve as governor of Maryland from 1987 to 1995. Below, Mayor Martin O'Malley gives a speech on Charles Street around 2005. O'Malley served as Baltimore's mayor from 1999 until 2007, when he, too, was elected governor of Maryland. (Both, courtesy of JMJR.)

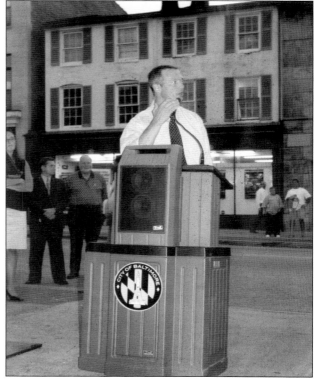

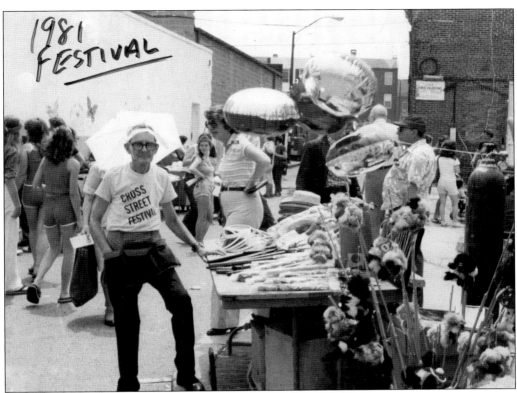

Since the early 1980s, downtown Federal Hill has been the site of a variety of street fairs, bringing residents from around the city to enjoy the neighborhood's unique charms. Above is an image from one of the very first, the 1981 Cross Street Festival. This vendor beats the heat with an umbrella hat while hawking his wares. The flyer to the right, from 1996, advertises another early fair, the South of the Harbor Funfest. That year's edition featured a new attraction, the Maryland Craft Beer Festival. Notice the thick crowd on Charles Street in front of the Cross Street Market. (Both, courtesy of JMJR.)

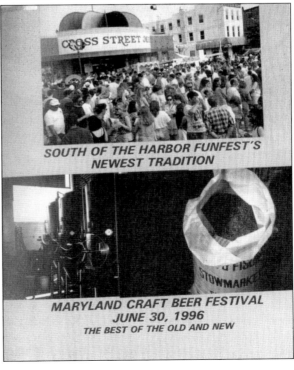

SOUTH OF THE HARBOR FUNFEST'S NEWEST TRADITION

MARYLAND CRAFT BEER FESTIVAL
JUNE 30, 1996
THE BEST OF THE OLD AND NEW

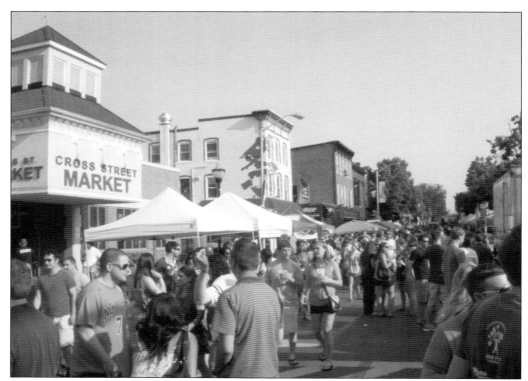

Federal Hill's festivals attract large, happy crowds. They include the Spring Block Party in April, the Jazz/Blues Festival in June, and the Street Beat and Federal Hill Wine Festivals in the fall. All of the events feature live bands, food from local restaurants, and plenty of merchandise to buy. Above, festivalgoers on Charles Street crowd the 2011 Jazz and Blues Fest. The festivals are sponsored by Federal Hill Main Street, a nonprofit organization created to revitalize the neighborhood's business district and attract Baltimore natives and tourists to the area. Below, musicians at the 2011 Jazz and Blues Fest keep the large crowd smiling. (Both, courtesy of AU.)

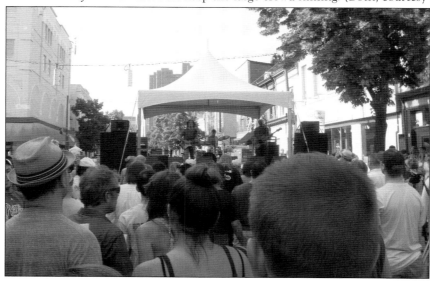

Three

SoBo Shops and Services

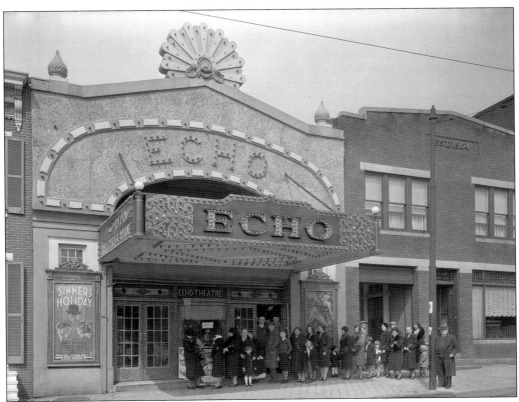

An eager crowd lines up for a matinee showing of *Sinner's Holiday* with James Cagney at the Echo Theater in 1931. The Echo stood at 124–126 East Fort Avenue just east of Light Street. The Echo opened around 1910 and was a relatively small theater for its time, having only 320 seats. (Courtesy of MHS.)

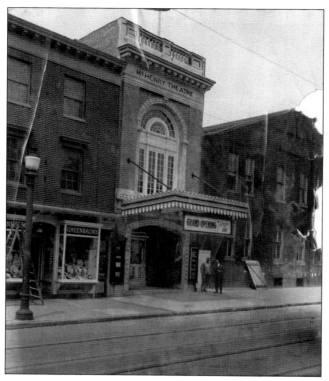

May 26, 1917, was opening day for the McHenry Theater. This grand movie palace featured a marble lobby and 1,200 seats. Besides the McHenry and the Echo, three more movie theaters served the area: the Casino Theater (later the Beacon) at 1118 Light Street; the Garden Theater at 1100 1/2 South Charles Street; and the Goldfield Theater at 924 South Sharp Street. The McHenry was the biggest of them all, and it was the last to close, in 1971. A Goodwill store opened there, then a sports arcade with batting cages. Finally, in 2001, a developer turned the structure into office space. But before that happened, there was one last picture show at the McHenry on August 28, 2001, with silent movies and free popcorn. (Left, courtesy of UMDL; below, courtesy of JMJR.)

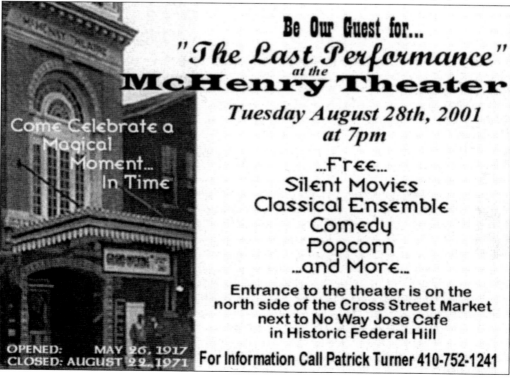

Be Our Guest for...

"*The Last Performance*"
at the
McHenry Theater

Tuesday August 28th, 2001
at 7pm

...Free...
Silent Movies
Classical Ensemble
Comedy
Popcorn
...and More...

Entrance to the theater is on the north side of the Cross Street Market next to No Way Jose Cafe in Historic Federal Hill

Come Celebrate a Magical Moment... In Time

OPENED: MAY 26, 1917
CLOSED: AUGUST 22, 1971

For Information Call Patrick Turner 410-752-1241

Federal Hill has long been the hub of SoBo's (South Baltimore's) shops and services. Here, in 1914, a wooden Indian reaches for the attention of a passerby on the 600 block of Charles Street. A men's clothing store displays its wares outside, and a misfit and sample parlor offers a crowded window full of bargains. (Courtesy of EPFL.)

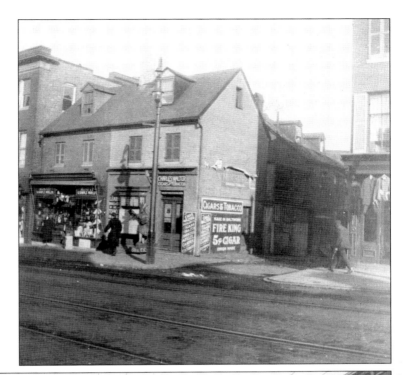

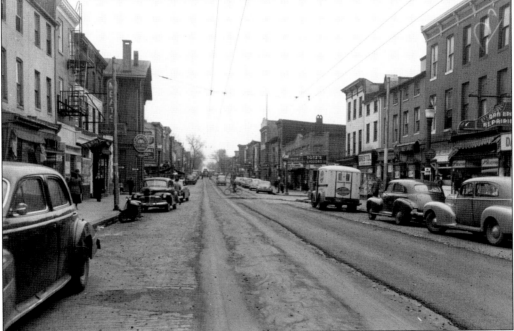

Looking south on the 1000 block of South Charles Street in the 1940s, the west side of the street, at right, features Dan Brothers Shoes, which is still operating (with new owners) in 2011. Farther down on the right is the Garden Theater. The old Cross Street Market stands directly across the street. The old market and Garden Theater have been demolished. (Courtesy of BMI.)

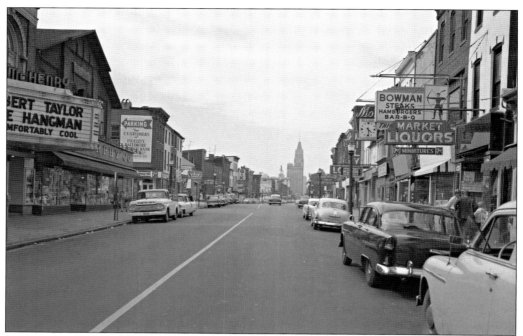

Looking north on Light Street from Cross Street, on July 6, 1959, Robert Taylor's latest film plays the McHenry, the Bowman is serving steaks, and three men chew the fat in front of Market Liquors, where there is a sale on Arrow Beer, seven for $1. Down the street, G&K Appliances has the latest RCA TVs, and Grieble Motors is selling brand new Ramblers. (Courtesy of BMI.)

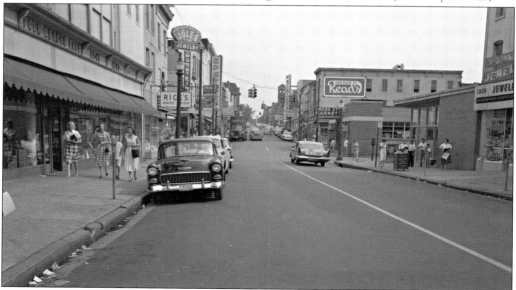

This view looks south on Light Street toward Cross Street, on the very same day as the photograph above. The Four Besche Brothers furniture store is on the immediate left. Beyond that are Rices' Bake Shop (famous for its Louisiana ring cake), Morstein's Jewelers, and Epstein's Department Store. The Cross Street Market sits across the street from Epstein's, totally rebuilt from a devastating fire five years before. (Courtesy of BMI.)

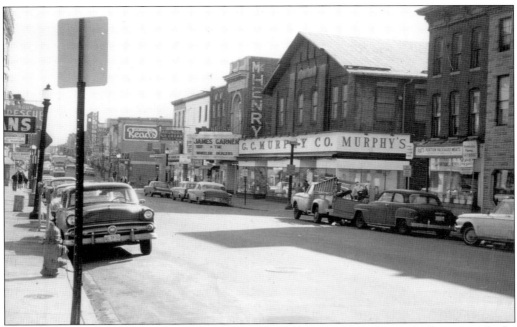

By November 1963, when these photographs were taken, one big change had come to Light Street: Morstein's Jewelers took its jewels and large sign reading "Jules for Jewelry" across the street. This photograph also shows G.C. Murphy and Company, the popular variety store chain. This one is fondly remembered for its lunch counter and 45-rpm records for sale. The photograph below shows the Arundel Meat Market and the Arundel Ice Cream Company as the McHenry Theater's next-door neighbors. The stores were connected inside. Though part of a local chain, the Arundel Ice Cream Company store was a real, old-fashioned malt shop, with a soda fountain and jukebox. Started in 1920, the chain claimed to sell more hand-dipped ice cream than any manufacturer in Maryland. (Both, courtesy of JMJR.)

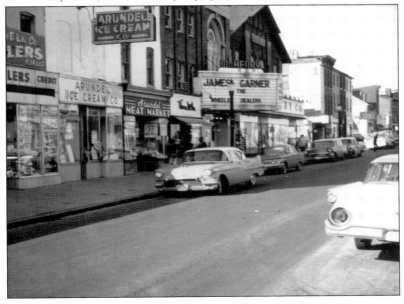

This image of Light Street (above) looking north offers a good view of the Cross Street Market. Next to the market are a Read's Drug Store and the Delly Gift Shop, which may or may not have had a pool hall above it. Also visible at right is Epstein's department store. The photograph, probably taken in 1971, shows the McHenry Theater shortly after it closed and was transformed into a Goodwill Store. The image below shows a closer view of the former theater. The McHenry is not the only Federal Hill institution that disappeared during this period. On the corner across the street, the Four Besche Brothers Furniture store has been torn down. The South Baltimore Recreation Center would be up and running at this location in 1972. (Courtesy of UMDL.)

In the 1970s, the heart of Light Street was not short of lunch counters or big colorful signs. The photograph at right shows the Baltimore version of Las Vegas, with Morstein's Jewelers, the Princess Shops, and Tommy Tucker's five-and-dime store vying for shoppers' attention. At the same time, lunch counters at George's and the White Coffee Pot's Family Inn competed for their stomachs. Across the street, below, the popular Baltimore sausage shop Polock Johnny's gives shoppers another filling lunch option. This Federal Hill outlet appeared during the brief period in the mid-1970s when Polock Johnny's owner John Kafka Jr. was offering franchises. After a sausage, shoppers could drop into another popular Federal Hill store from the period, Al Bass, which offered fine men's sportswear. All of Light Street's large signs were removed in 1973. (Courtesy of JMJR.)

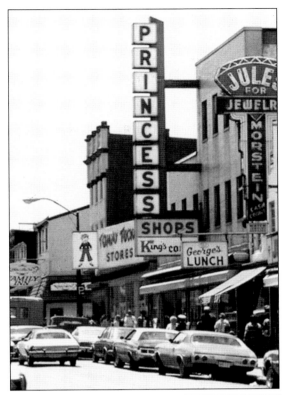

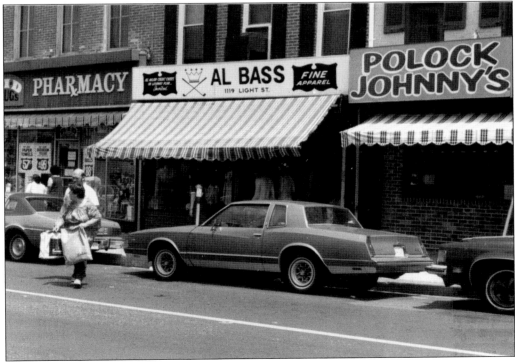

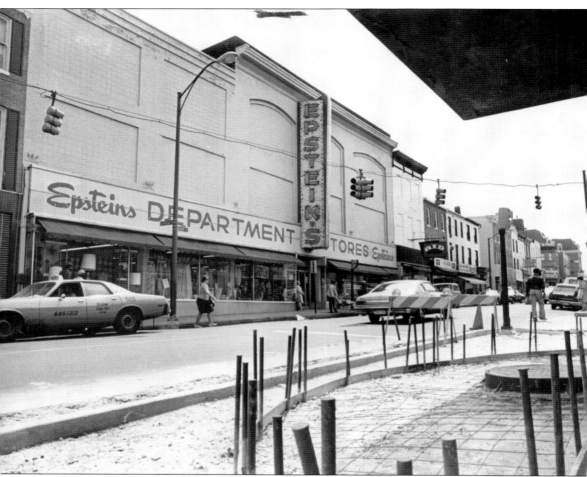

Epstein's was not only an institution in Federal Hill, but the discount department store chain was a staple in many of Baltimore's blue-collar communities. Founded in 1926, the outlet at 1100–1200 Light Street opened in March 1953. Along with Four Besche Brothers Furniture, Shofer's Furniture, and the Cross Street Market, it quickly became an anchor of the Federal Hill shopping district. Parochial-school uniforms, curtain rods, wastebaskets, and all-purpose cotton-polyester housecoats with metal snaps—called "snappers"—were among Epstein's perennial best sellers. Full-page ads in the Sunday papers led to lines outside the door before opening time on Monday mornings. The sales force was largely made up of local women who made a direct connection with the store's biggest customers, working-class women like themselves. However, Epstein's fell victim to competition from national chains such as Target and Kmart. The store in Federal Hill closed in 1990. When Epstein's shut down completely the following year, it was the last great family-owned department store in Baltimore. (Courtesy of UMDL.)

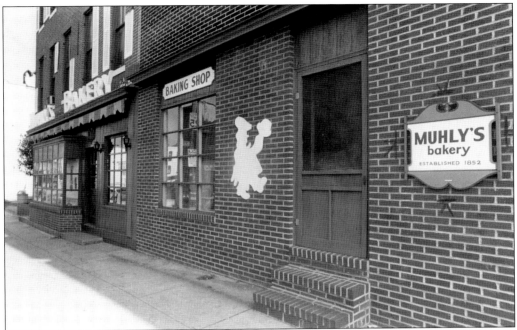

Federal Hill has been well served over the years by several successful family businesses. One of the most beloved and legendary was Muhly's Bakery, at 1115 South Charles Street. It was founded at the same location in 1852 by German immigrant Eberhard Muhly, who had built a large brick oven in his backyard. When the Union army occupied Federal Hill, it commandeered the bakery. One of the specialties at the time was gingerbread. Over the years, Muhly's became famous for its peach cake, Baltimore cheesecake (thinner than normal cheesecake and served with currants), and Federal Hill cake—a pound cake with cream inside. Below, bread is loaded into the bakery's new cooling room in 1934. The family sold the business in 1991. It was replaced by the popular bar/restaurant Mother's. (Courtesy of UMDL.)

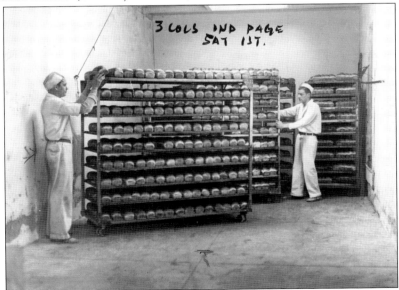

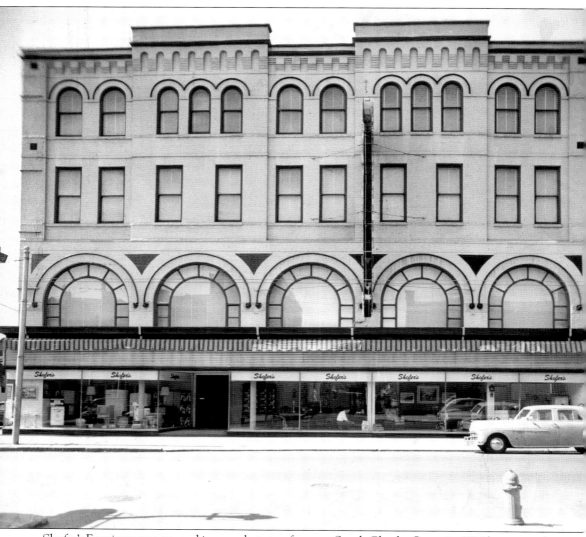

Shofer's Furniture was opened in a modest storefront on South Charles Street in 1914 by a recently arrived 17-year-old Lithuanian immigrant named Harry Shofer. In the early 1930s, Shofer had become successful enough to move his business across the street to this building at 930 South Charles Street, which had recently been abandoned by Hecht's department store. The furniture company occupies all five floors, totaling more than 70,000 square feet of showroom space. Shofer's specializes in high-quality furniture, and for a while even sold big-ticket appliances. It was one of the first stores in the neighborhood to offer a layaway policy to make products available for lower-income customers. Harry Shofer had many brothers, and some had businesses in the neighborhood. Reuben Shofer opened a tire store on Hamburg Street. Another brother, Bernie Shofer, opened his piano store at 828 South Charles Street. Harry's son Herb would follow in his father's footsteps to run the business, and Herb's son Hank is currently president of the company. (Courtesy of HS.)

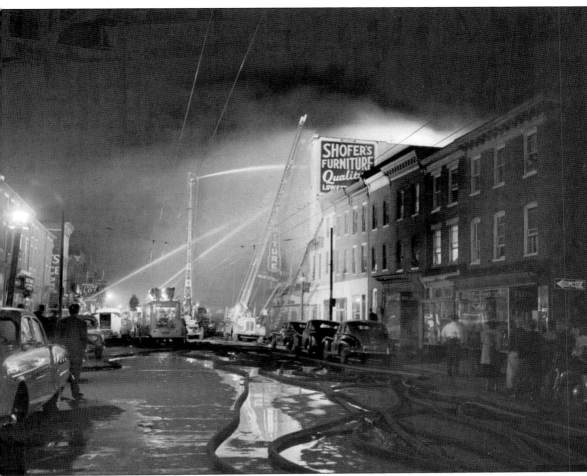

Just before 2:30 a.m. on May 27, 1953, a fire began to consume Shofer's Furniture. Flames were seen shooting from every window on the south side of the building. A corrugated canopy made of plastic and metal that hung over the sidewalk was engulfed in the blaze. As fire engines arrived, the fire continued to burn out of control, with flames shooting through the roof and high into the air. The fire eventually became a six-alarm emergency, but was put under control and extinguished before the building burned down. Amazingly, in spite of extensive damage to the building and many thousands of dollars in lost merchandise, the Shofer family persevered, and the store soon reopened. Today, in the same location, it remains one of the most prestigious furniture stores in Baltimore. (Courtesy of MHS PP79.504.)

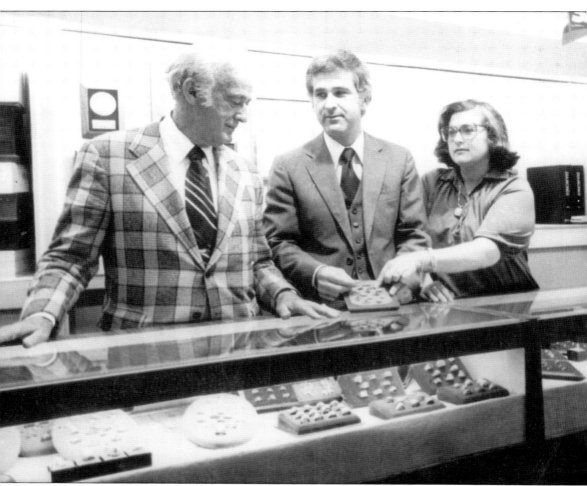

Like Shofer's, Morstein's Jewelers is another family-owned business in Federal Hill that has been passed down for three generations. William Morstein, who had recently emigrated from Russia, opened a jewelry store in East Baltimore in 1898. Eight years later, he moved the business to Federal Hill. William's sons David and Jules took over the shop and by 1939 had built one of the largest jewelry businesses in Baltimore. But in 1953, Jules split with his brother and opened a competing jewelry store on the same block, hanging out a large sign that read, "Jules for Jewelry." Eventually, David closed his store and once again there was a single Morstein's Jeweler. In this photograph taken in the early 1970s, Jules Morstein Sr. talks business with his son Jules "Sonny" Morstein Jr. and daughter Nancy Boltz, who had joined him in the business. Sonny and Nancy took over Morstein's Jewelers when their father retired in 1984. (Courtesy of JMJR.)

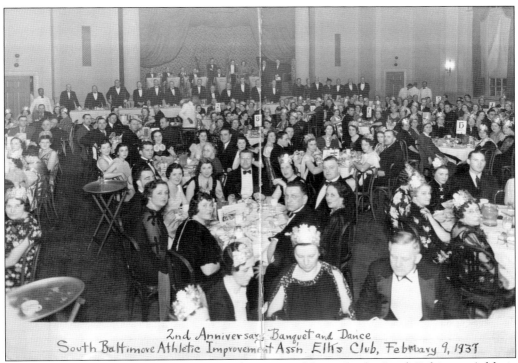

2nd Anniversary Banquet and Dance
South Baltimore Athletic Improvement Ass'n Elks Club, February 9, 1937

Above is a picture of the second anniversary banquet and dance for the South Baltimore Athletic Improvement Association, at the Elks Club on February 9, 1937. Jules Morstein Sr. was an early booster of physical fitness and remained so throughout his life. He and his wife, Bertha Rose, sit in the second row of tables at left. He is at the front, turning to face the camera; she sits to his left. Morstein's Jewelers sponsored several sports teams over the years. Below, a 1930s-era basketball team sports the company name and an impressive looking trophy. Dave Morstein sits in the suit at far left. This team may have played in the Cross Street Market. The old two-story market had a gym on the second floor often used by community teams. (Courtesy of JMJR.)

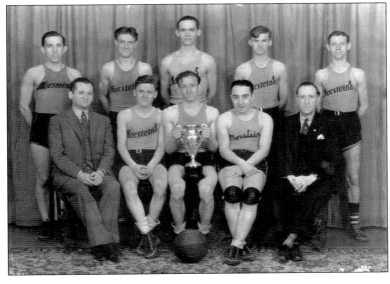

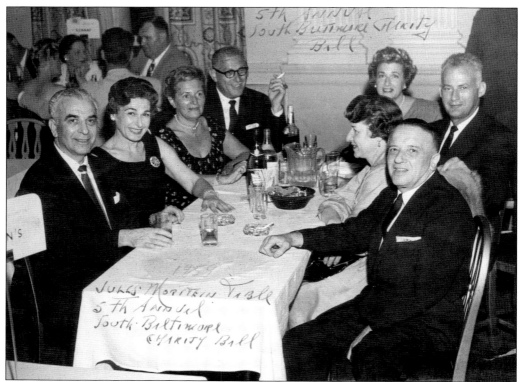

Jules Morstein Sr. (third from right) and his wife, Bertha Rose (behind him), share a table with friends and business associates at the fifth annual South Baltimore Charity Ball in the early 1960s. Jules was very active in the South Baltimore business community and served as president of the South Baltimore Businessmen's Association—a position also held by two of his children. When his daughter Nancy took over the reins, she changed the name to the South Baltimore Business Association. Jules Morstein Jr. served as president of the association from 1987 through 2001, overseeing the group's largest period of growth. Below, he shows the store's wares to Baltimore's first African American mayor, Kurt Schmoke, who visited the store to make a purchase in the early 1990s. (Courtesy of JMJR.)

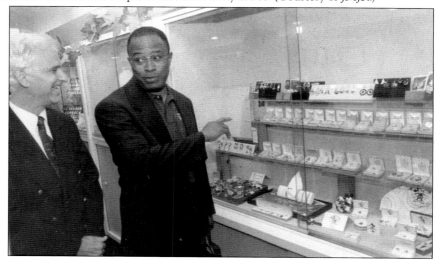

The photograph at right shows Morstein's Jewelers employee Shirley Wagner in front of the store in her prom dress in the mid-1940s. Wagner remained a loyal employee of the store for more than 60 years. Below, Jules Morstein Jr. (fourth from right) escorts Maryland governor Parris Glendening down Charles Street in the late 1990s. Morstein's tenure as president of the South Baltimore Business Association gave him the opportunity to rub shoulders with local and state politicians, earning him the unofficial title "Mayor of South Baltimore." Governor Glendening, who served from 1995 to 2003, shakes hands in front of the popular Japanese restaurant Matsuri. The bar Mother's stands directly behind the governor, at the former location of Muhly's Bakery. (Courtesy of JMJR.)

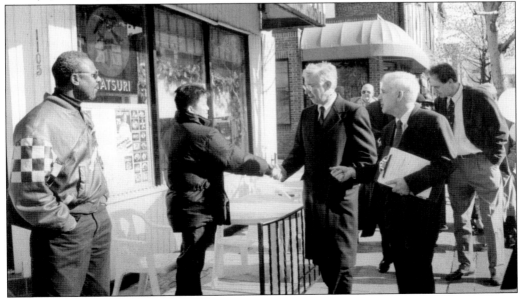

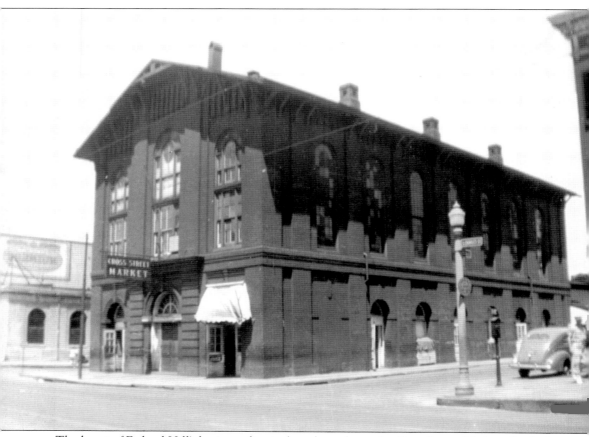

The heart of Federal Hill's business district has always been the Cross Street Market. By the late 1800s, the population of Federal Hill had grown to the point where residents petitioned the city for a local market of their own, like Lexington Market downtown and the Broadway Market in Fell's Point. At the time, the closest market was the Hanover Street Market built in 1784 at the corners of Hanover and Camden Streets. In 1846, the city designated a stretch of land on Cross Street between Charles and Light Streets for a new market. A couple of open-air structures housed the Cross Street Market until this two-story brick building was constructed in 1871. Designed by architect Frank Davis, it was slated to cost $25,000, but the final price tag was $17,500 more. The solid brick building included a large public hall on the second floor for dances and athletic activities. It took up about a third of the block. A long single-story wooden structure composed the rest of the market. (Courtesy of EPFL.)

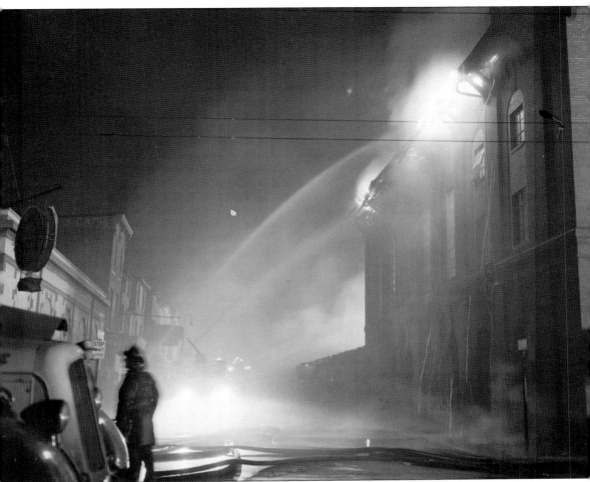

Since the moment the building opened, the Cross Street Market was one of the unrivaled centerpieces of the neighborhood. But at around 1:30 in the morning on May 19, 1951, tragedy struck. A fire began in the fish-produce section of the main building and spread very quickly. It resulted in a 12-alarm fire that many South Baltimore residents will never forget. Balls of fire shot high into the air, torching shops and residences on the south side of Cross Street. Homeowners took to their roofs, pouring water on them to no avail. Several inebriated men who had used the market stalls to sleep in had to be rescued by firemen. The market's recently tarred roofs eventually collapsed inside the building. Seventy pieces of equipment battled the blaze, but in the end, the market was a total loss. Eighty-one-year-old J.L. Harvey, who had manned his butter-and-egg stand in the market for 69 straight years without a vacation, was quoted as saying, "Now I've got a vacation, and I don't want it." (Courtesy of MHS PP.79.385.3)

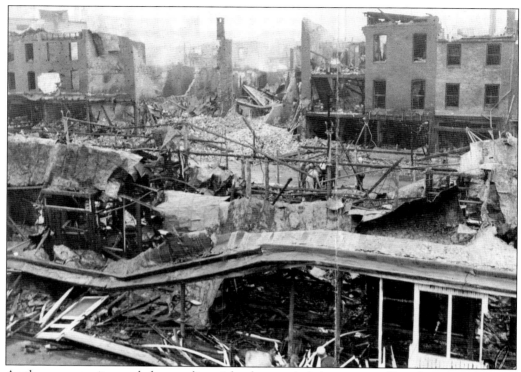

As the sun rose, it revealed a startling sight that reminded everyone of London after the blitz. The photograph above shows not only the gutted market but also some of the 13 buildings on the south side of Cross Street that were also destroyed. A 10-year-old boy was eventually charged with starting the multimillion-dollar fire. However, this was hardly the end of the Cross Street Market. The photograph below, taken in February 1952, shows the old market rubble cleared away and the foundations for a new market begun. This rare glimpse of a market-free Cross Street reveals the shops on the north side of the street. The Garden Theater is visible on Charles Street, at upper left. (Above, courtesy of UMDL; below, courtesy of MHS MC5013.)

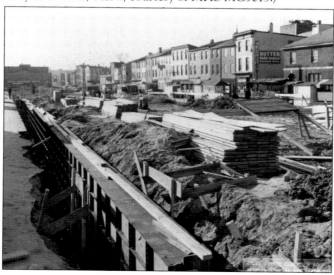

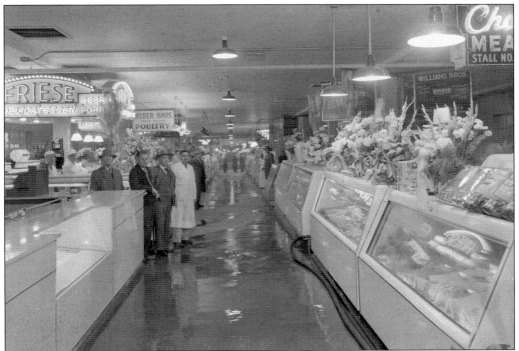

The new Cross Street Market opened exactly 18 months to the day after the fire, on November 19, 1952. The grand opening came complete with bunting and a speech from Baltimore mayor Thomas D'Alesandro Jr., father of future Speaker of the House Nancy Pelosi. It was attended by some 20,000 people and boasted the slogan Save More in South Baltimore. The photograph above shows the inside of the brand-new market on opening day. Below is a view of the bustling market in the summer of 1973. Always more than just a place to buy goods and produce, the Cross Street Market also serves as a social center within the community. (Above, courtesy of MHS PP30.838.52; below, courtesy of UMDL.)

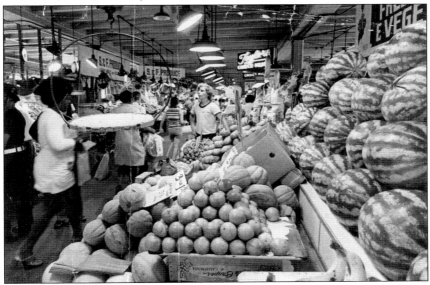

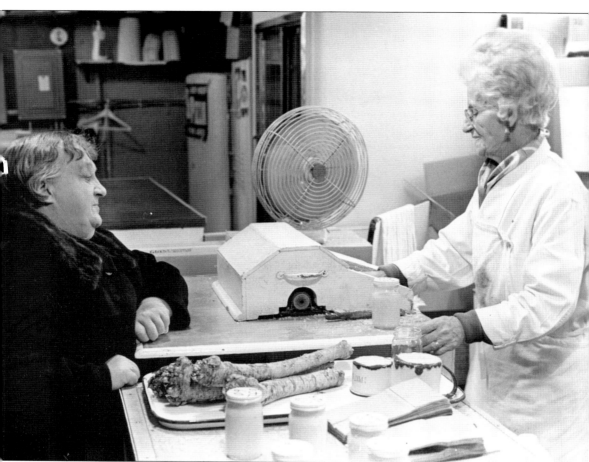

Meat and produce were not the only things that attracted people to the stalls of the Cross Street Market. A special bond between merchants and customers also played a big part in the market's popularity. Among those special personalities was Myrtle Pancoast, also known as the "Horseradish Lady." Pancoast first began working in the market with her husband in the early 1920s. By the end of that decade, they began specializing in fresh horseradish, a favorite ingredient in foods made by the German, Polish, and Jewish residents of Federal Hill. Neighbors remembered tiny Myrtle—who was barely five feet tall—lugging big burlap sacks full of horseradish into her backyard and preparing them for market. At her stall, she grated it fresh, and then mixed it with vinegar and water before selling it in half-pint jars. But as much as the product, it was Myrtle's easy conversation and sweet personality that kept customers coming back. She worked at the Cross Street Market for more than 50 years until her death in January 1978. (Courtesy of UMDL.)

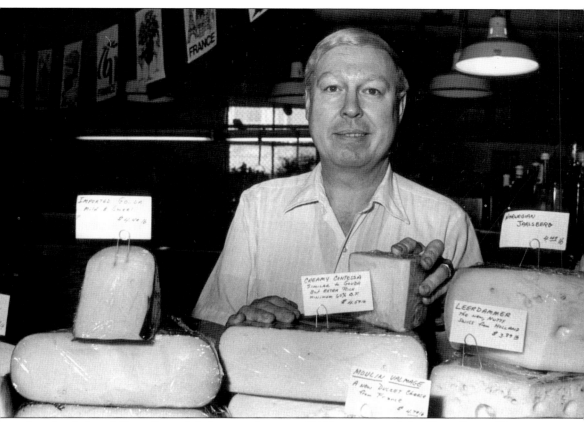

Another beloved Cross Street Market merchant was Ed Byer, owner of the Cross Street Cheese Company. Byer was a big man and an opera-lover who studied voice at the Peabody Conservatory of Music. He was the lead tenor in several church choirs and became a bank vice president in the late 1970s. It was around that time he bought and restored a row house in Otterbein. Ed opened his stall in the market in 1981. He later remembered offering 15 different cheeses at that time. By the time he sold the stand in 1993, he stocked 135 varieties. Customers began to depend on his knowledge of cheeses and to relish the stories he swapped with them about life and music. Many credited Ed's cheese shop with attracting a more sophisticated clientele to the market. When this photograph was taken around 1990, Ed also ran a successful catering business, making what one customer fondly recalled as "the best sour beef in Baltimore." Ed Byer passed away at age 60 in 1999. (Courtesy of JMJR.)

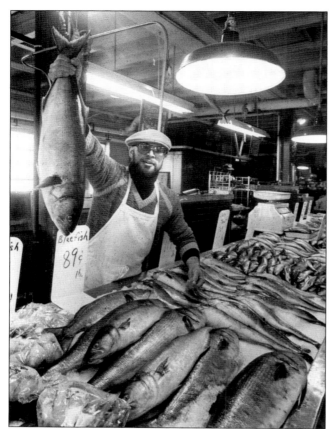

At left, third-generation fish merchant Lou Chagouris holds a prime catch at his stall in 1980. His grandfather and great-uncle started a seafood business called Chagouris and Matthews in 1917. Lou and his brother Nick moved to Texas, where they opened a restaurant and fish market. Below, busy South Baltimore shoppers join the foot traffic on Light Street near the Cross Street Market around 1970. In those days, the Cross Street Market and other shops in the business district primarily served the needs of the neighborhood. But with the building of the stadiums for the Baltimore Orioles and Baltimore Ravens near Otterbein in the 1990s, and an influx of new restaurants and bars, the neighborhood has become a popular destination for tourists as well as residents from all over the city. (Left, courtesy of UMDL; below, courtesy of JMJR.)

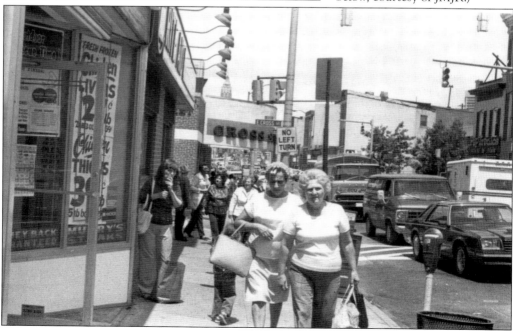

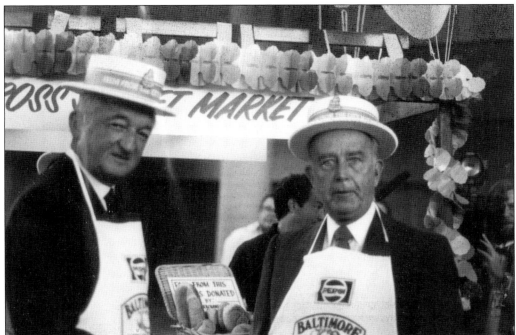

Of course, where crowds gather, politicians soon follow. Above, Baltimore mayor William Donald Schaefer appears at the Cross Street Market with Frank Perdue, president and CEO of Perdue Farms, one of the nation's largest chicken producers. The photograph was taken at a city fundraiser in the 1970s. Below, South Baltimore Business Association president Jules Morstein lets Baltimore mayor Kurt Schmoke cut the cake at a market party in the late 1990s. Morstein was instrumental in convincing Mayor Schmoke to sign off on a much needed neighborhood parking garage after the Baltimore Ravens stadium, built in 1998, brought new traffic to Federal Hill. The mayor's appearance at the market was part of a thank-you party sponsored by the SBBA. (Courtesy of JMJR.)

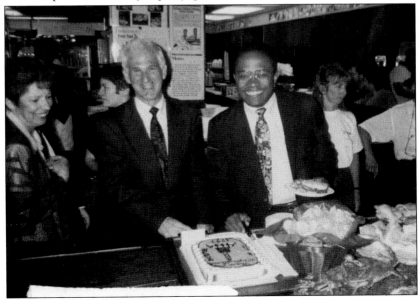

In the late 1970s, when these photographs were taken at the Cross Street Market, an independent newspaper based in Federal Hill called *The Enterprise* ran an in-depth oral history of the market, interviewing many of the older merchants and their families, friends, and customers. Through their different voices emerges a unique American story of hardworking, humble people and their equally hardworking community. Most merchants with stalls at the Cross Street Market put in 12 hours a day or more every day but Sunday, when it was closed. Some of them never took a vacation. Their children were recruited into the business at a young age, and more than one continued the family business in the market. None got rich, but all were proud of what they did and where they did it. (Both, courtesy of JMJR.)

Four

SHIPBUILDING AND INDUSTRY

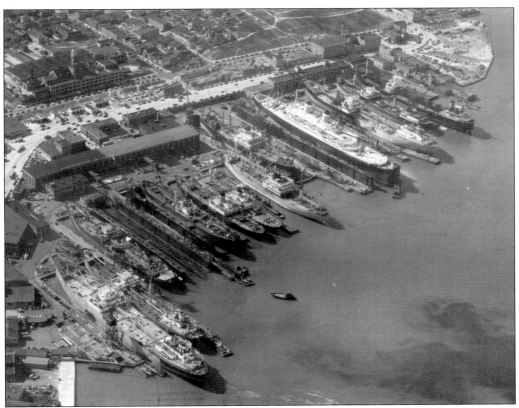

The Bethlehem Steel Shipyard at the foot of the park (upper right) dominates the view along Key Highway in this 1954 photograph. The large United States Printing & Lithography Company plant (formerly American Label Manufacturing) at Cross and Covington Streets can also be seen behind the shipyard. In the background are the streets where many workers made their homes. (Courtesy of BMI.)

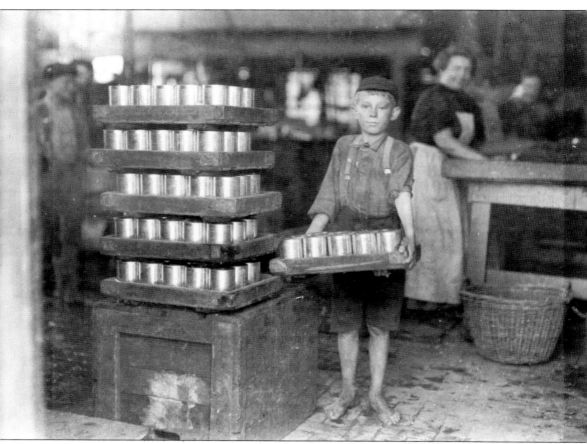

Oyster canning became a thriving business in Baltimore by the mid-19th century due to the availability of oyster beds nearby, easy access to sea and rail transport, and a ready supply of workers. One of the earliest oyster canneries was established in Federal Hill by Thomas Kensett in 1826. The job of opening, or shucking, steamed oysters was often done by women, as shown in this photograph, and sometimes even by children. By 1870, it is estimated that there were some 100 canning companies in the city, including a number of large canneries along the east shore of Federal Hill, where workers canned oysters in the spring and fruits and vegetables the rest of the year. Little evidence of these thriving businesses remains today, as they were replaced by the Bethlehem Steel Shipyard in the 1920s. One exception is the old Platt & Company cannery building on Key Highway that now houses the Baltimore Museum of Industry, inside of which visitors can find an exhibit highlighting and demonstrating the history of the canning industry in Maryland. (Courtesy of LOC.)

Early in the 19th century, shipbuilding in Baltimore was associated with clipper ships, most of which were built in the shipyards in Fells Point. The emergence of steam-powered vessels, however, established Federal Hill as a force in the shipbuilding industry. The foot of Federal Hill was the site of many shipbuilding companies over the years. In the photograph above, taken in 1903, Oliver Reeder and Sons (at lower right) sits among the bustling industrial enterprises that sprang up along Key Highway. In the photograph below, the large brick building at bottom right is the federal terminal for the United Fruit Company Steamship Line. Its ships provided regular passenger, mail, and freight service between the Atlantic ports, the West Indies, and South America. The steamship, belonging to the Bluefields Steamship Company, operated primarily between the United States and Nicaragua. (Both, courtesy of LOC.)

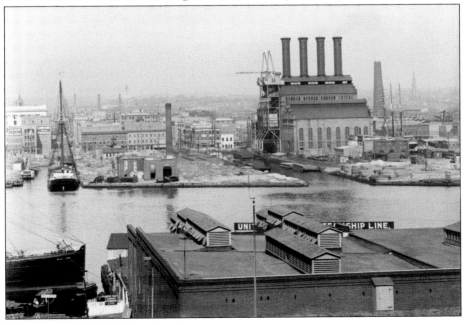

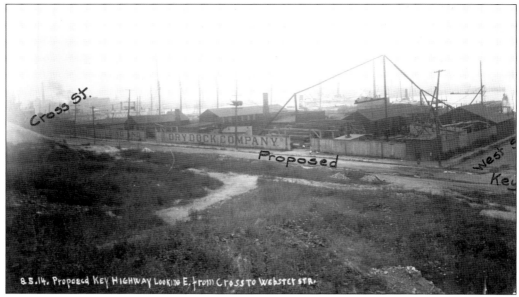

Before there was Key Highway, there was . . . this. The photograph above, taken in 1914, shows Skinner Shipbuilding and Dry Dock Company as it sat at the end of Cross Street. By then, the bustling shipping business at the foot of Federal Hill required a much bigger—and paved—road. Key Highway was built to solve the problem. Below, Key Highway stretches south past the Bethlehem Steel Shipyard in a photograph from 1954. An armada of limping boats waits for repairs. The crowded yard employed hundreds of workers, many of whom packed their lunches and walked to work from Federal Hill. The job, however, came with risks, both from handling heavy machinery and, as was later determined, possible exposure to asbestos. (Above, courtesy of EPFL; below, courtesy of BMI.)

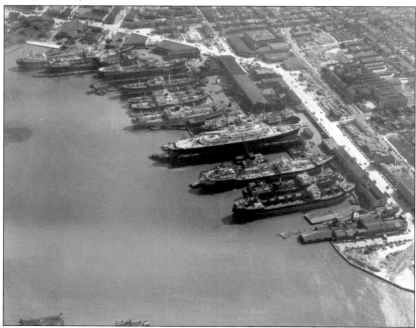

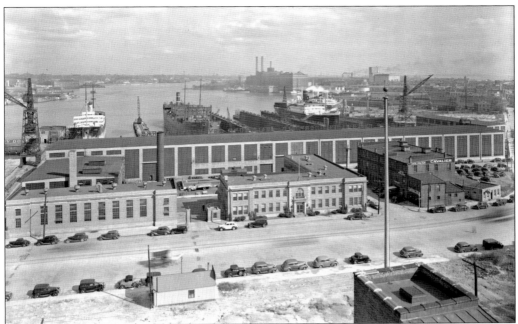

In 1921, Bethlehem Steel bought all the properties of the Baltimore Dry Dock and Building Company. This photograph from 1930 shows the company's dry docks and marine railways used to conduct ship repair work along Key Highway. The company also had a ship repair yard near Fort McHenry. Two other Bethlehem shipyards, Fairfield and Sparrows Point, specialized in new construction—notably the Liberty Ships. After the outbreak of World War II, Bethlehem needed more room to fulfill war contracts, so its Key Highway Repair Yard was employed, as shown in the photograph below, handling more than 1,600 ships during the war. Work included installing armor plates and gun platforms on merchant ships, converting passenger ships to troop-transport ships, and repairing damaged vessels. (Both, courtesy of BMI.)

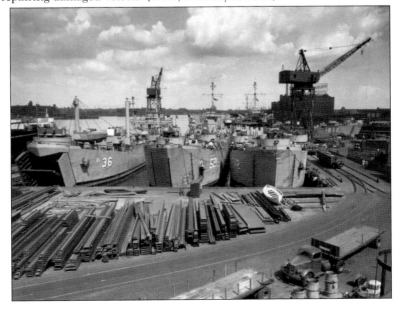

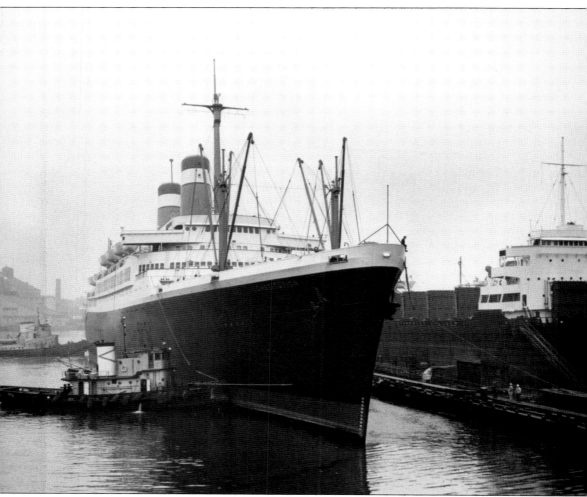

The SS *Constitution* was a liner that was part of the American Export Lines fleet. It was commissioned in 1951 and sailed various routes from New York to Europe. It weighed 30,293 tons and was 683 feet long. In 1956, Grace Kelly sailed aboard the glamorous ocean liner from New York to Monaco for her wedding to Prince Rainier. The ship is also featured in the popular 1957 romantic film *An Affair to Remember*. But on March 25, 1954, before these glory days, it sailed to Federal Hill's Bethlehem Steel Shipyard to repair severe damage to its starboard reduction gears. Bethlehem's large-capacity equipment and 22-ton floating drydock were well suited to make the extensive repairs. In this photograph, the luxury liner prepares to dock in the Baltimore Harbor assisted by several tugs. The boat was treated like a star, and this was one of the most celebrated repair jobs conducted on Key Highway. (Courtesy of BMI.)

The first task facing workers was preparing the opening in the shell to remove the faulty equipment. As there was not enough clearance between the side of the ship and the wall of the dry dock for some of the removals, a section of the wing wall had to be removed. The section was removed in one piece so that it could be quickly replaced. (Courtesy of BMI.)

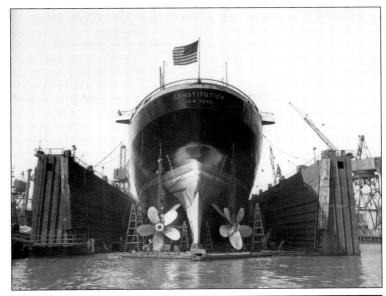

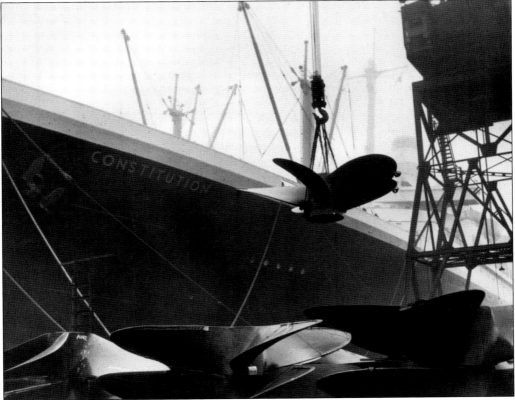

Particularly challenging was the removal of the 35-ton bull gear. It was lifted out of position with chain falls, set on a skid, then rolled out of the hull opening. The bull gear was lifted clear of the ship on the afternoon of March 29, just 60 hours after the vessel went in the dry dock. The operation was then conducted in reverse to install the new gears. (Courtesy of BMI.)

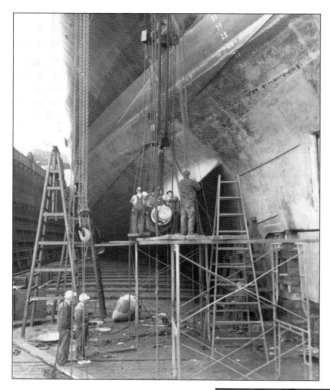

While the ship was in dry dock, its shafts and propellers were removed for their annual inspection. Afterward, the parts were reinstalled. This photograph shows the massive propellers being lifted. Once this was done, all underwater work had been completed, and the boat was now ready to come off the dock. (Courtesy of BMI.)

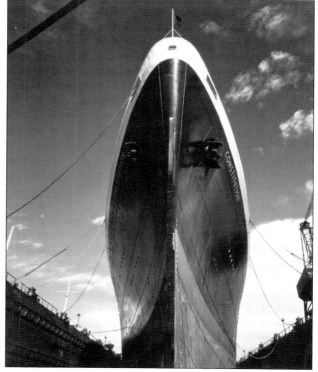

On Friday, April 2, the signal was given to sink the dock and refloat the ship. By that afternoon, it was once again moored to Pier 1 in the Inner Harbor, just eight days after the workers at Bethlehem Steel Shipyard began the complicated repairs. After a short dock trial to test the efficacy of the repairs, the SS *Constitution* sailed back to New York on April 13, 1954. (Courtesy of BMI.)

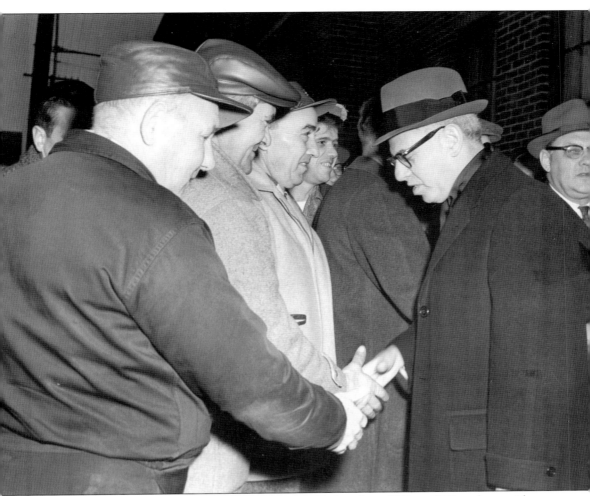

In this photograph, Arthur J. Goldberg, Secretary of Labor from 1961 to 1962 under president John F. Kennedy, greets workers at the Bethlehem shipyard on Key Highway. Goldberg had been general counsel for the steelworkers union during the 1959 strike, during which 85 percent of US steel production was shut down for almost four months. The great steel strike of 1959 lasted 116 days, from June 15 to November 7, and only ended after intervention by President Eisenhower and the Supreme Court. It is said to have laid the seeds for the decline of the American steel industry, as during the strike, American industries began importing steel from foreign sources. In 1957, Bethlehem Steel employed about 30,920 workers in Baltimore, including the shipyards and the plant at Sparrows Point just outside of the city. Today, only the steelworks at Sparrows Point remain under the ownership of RG Steel, with a drastically reduced number of workers and an uncertain future. (Courtesy of EPFL.)

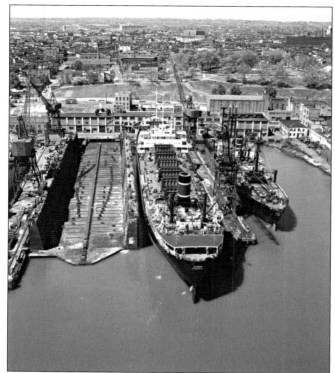

At left, a 1963 aerial view of the Bethlehem Steel Shipyard on Key Highway shows portions of South Baltimore along the highway as well as the ships docked at the piers. Below, on a bright spring day in March 1973, an unidentified boy rides his bicycle on tiny Folsum Street as two large ships raised in dry dock loom in the background. Bethlehem Steel Shipyard was indeed a big part of the Federal Hill community, not only visually, but also because it employed hundreds of residents. Bethlehem Steel closed the Key Highway Shipyards on December 31, 1982. The site was redeveloped as the Harbor View residential community. A 26-story highrise stands over the shipyard's permanent dry dock. (Left, courtesy of BMI; below, courtesy of UMDL.)

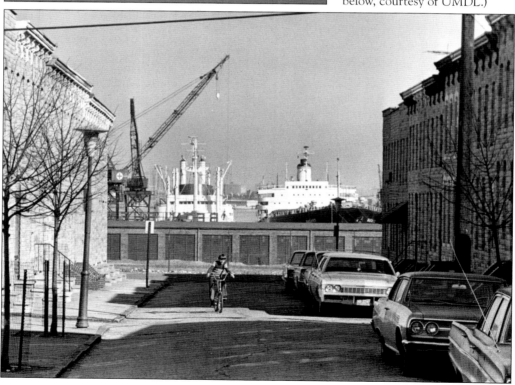

Its proximity to the harbor made Federal Hill a desirable location for businesses that supported the shipping industries. In 1922, the Virginia Barrel Company, of Winchester, Virginia, bought a facility on Leadenhall and Ostend Streets, which had previously housed an old hopper shop for the Baltimore & Ohio Railroad. The company established a factory there for the manufacturing of wooden casks or barrels. The photograph at right shows workers operating the barrel-making machinery on September 28, 1955. The image below, taken on November 9, 1956, is of skilled workers pouring molten steel into molds at the Central Pattern Company on 47 West West Street. Industrial pattern-making companies made patterns for forming and molding metal. These were used by other companies to produce metal ornaments, tools, automobile parts, cutlery, and other goods. (Both, courtesy of BMI.)

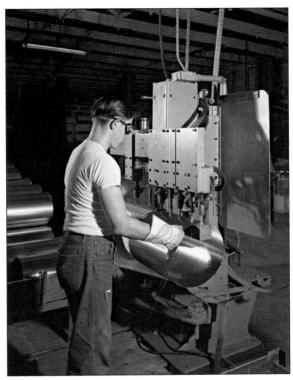

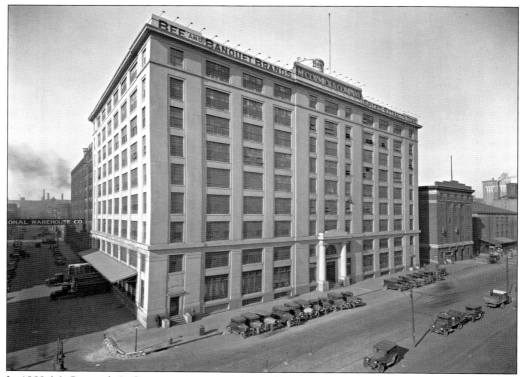

In 1889, McCormick & Company was started in Baltimore in one room and a cellar by 25-year-old Willoughby M. McCormick. By 1921, a new nine-story home for the House of McCormick was built at Baltimore Harbor. The McCormick Building on Light Street, shown above around 1930, was a prominent feature along the Inner Harbor for many years. The McCormick Company was trading with the East and West Indies, South Africa, Europe, and Central and South America. Spices from around the world arrived through the Port of Baltimore. The photograph below from the late 1970s shows McCormick & Company at right and its proximity to Federal Hill and the surrounding neighborhood, where scents of cinnamon, nutmeg, and other spices filled the air. (Above, courtesy of BMI; below, courtesy of UMDL.)

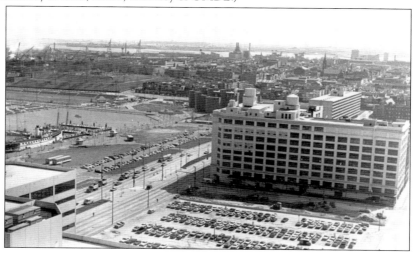

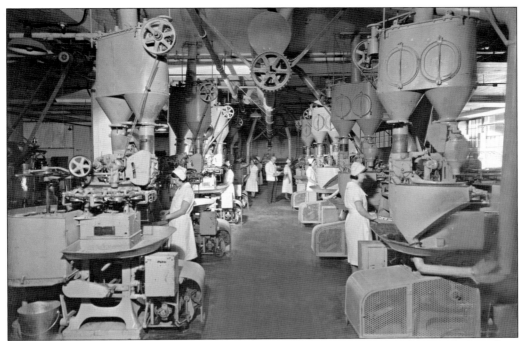

In the photograph above, workers fill spice containers in 1934. Four years later, McCormick researchers developed a spice sterilizing process they crowned "McCorization," which made the processing of spices safer and cleaner without loss of flavor. In 1910, McCormick was at the front of the line with another innovation by selling tea in gauze pouches, or tea bags. In 1934, Baltimore architect Edwin Tunis designed and constructed an early English teahouse on the seventh floor of the Light Street Building. In the photograph below, tea-tasters test samples from the Banquet Tea line. After McCormick and Company moved from Light Street to the suburb of Hunt Valley, Maryland, in 1989, the fragrant landmark was demolished, but the English teahouse was preserved and moved stone by stone to the new corporate headquarters in Sparks, Maryland. (Both, courtesy of BMI.)

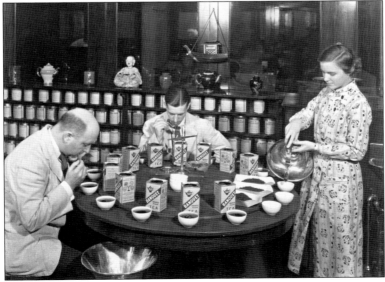

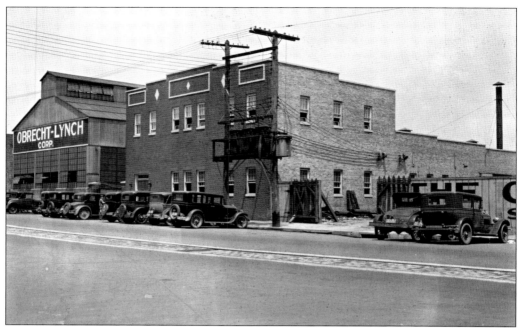

At its peak in 1929, Baltimore's streetcar system had over 400 miles of track. In Federal Hill, streetcars went down Light Street, with one line continuing straight through to the business district and another line branching down Key Highway past Federal Hill Park. In the c. 1930 photograph above of the 1400 block of Key Highway, the old streetcar tracks are visible. The factory in the background, Olbrecht-Lynch Corporation, was a manufacturing plant. Currently, it is home to the General Ship Repair Company, seen below, the last remaining ship-repair company and dry dock on Key Highway. (Above, courtesy of BMI; below, courtesy of AU.)

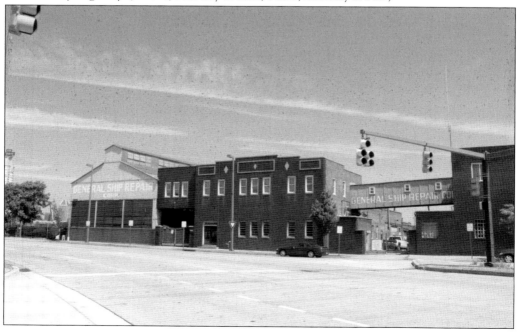

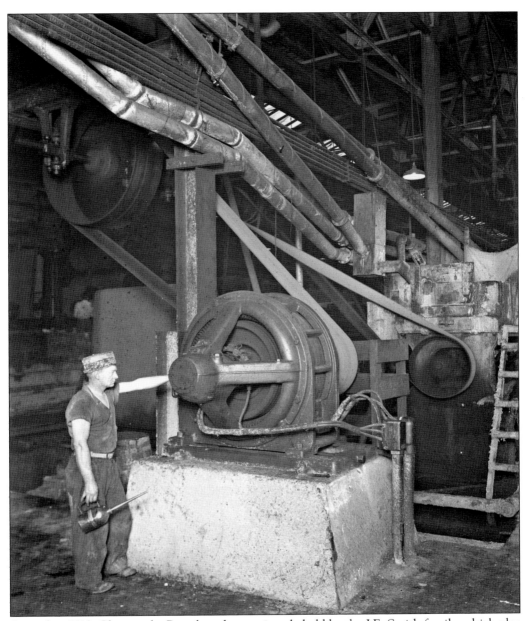

Started in 1910, Chesapeake Paperboard was privately held by the J.E. Smith family, which also owned the J.E. Smith Company in Millersville, Maryland, which made rigid boxes, and the Chesapeake Fiber Packaging Company based in Cockeysville, Maryland, which made folding boxes. Located on Key Highway and Fort Avenue, Chesapeake started out as a paper mill. By 1999, it was the sole handler of 15,000 tons of waste paper collected annually by Baltimore's curbside recycling program. The company accepted the paper for free rather than charging a fee, as many recyclers did. In exchange, the city disposed of a set portion of Chesapeake's waste without charge. Plagued by financial difficulties, the company was sold, and the new owners closed the paper mill in 2000, throwing 100 people out of work. The old plant was demolished and is the site for a new residential, shopping, and office complex. (Courtesy of BMI.)

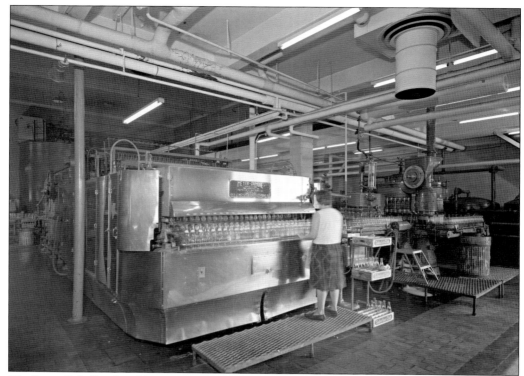

The Pepsi-Cola Bottling Plant enjoyed prime real estate right off the harbor on Key Highway. In the photograph above, a woman operates a bottle-washing machine in 1961. Sadly, this is around the time when many of the blue-collar jobs that employed so many Federal Hill residents, and defined the neighborhood, began to fade. Within the next 20 years they were nearly all gone, and Federal Hill would not be the only neighborhood to suffer. The same thing was happening to plants all over the city. Still, recalling the handsome Pepsi Building (below) at 400 Key Highway brings a smile to longtime Federal Hill residents. (Above, courtesy of BMI; below, courtesy of UMDL.)

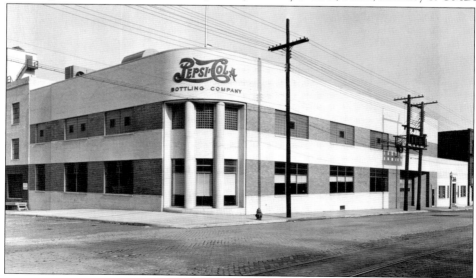

Five

RELOCATION AND RENOVATION

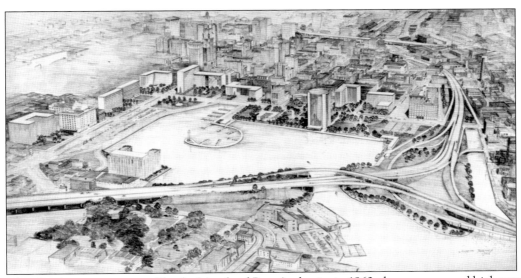

This drawing, commissioned by the Maryland Port Authority in 1963, shows a proposed highway route that would connect the new I-95 expressway with I-83 and I-70. I-95 would then continue along the southern boundary of Fells Point. Many homes in Federal Hill and Fells Point were threatened by the proposal, although in this plan, Federal Hill itself is actually spared. (Courtesy of UMDL.)

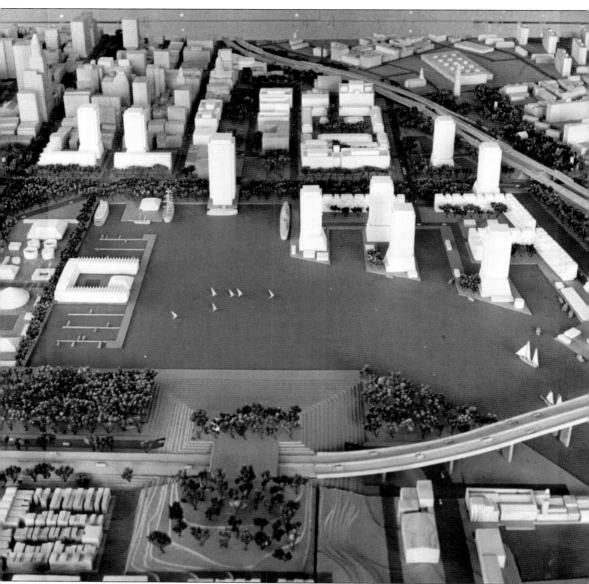

This model, envisioned by the Greater Baltimore Committee in 1964, replaced the previous year's plan. In the new version, the northern portion of Federal Hill Park would be sliced off. A bridge connected it to a man-made park created on the other side of the highway. In the eyes of the planners, this design actually doubled the size of the park. In addition to severely altering the park, the highway meant the razing of hundreds of homes in the Federal Hill, Otterbein, Sharp Leadenhall, and Fells Point neighborhoods. Near Federal Hill, historic row houses on Sharp, Leadenhall, Hill, Lee, Montgomery, Hamburg, Hughes, and Charles Streets were scheduled for the wrecking ball. Of course, the homes on adjacent blocks would have been greatly affected by a roaring highway that would eventually run the length of the entire East Coast, from northern Maine to the southern tip of Florida. Federal Hill residents had a lot to be concerned about as the plan gained the support of city hall. (Courtesy of UMDL.)

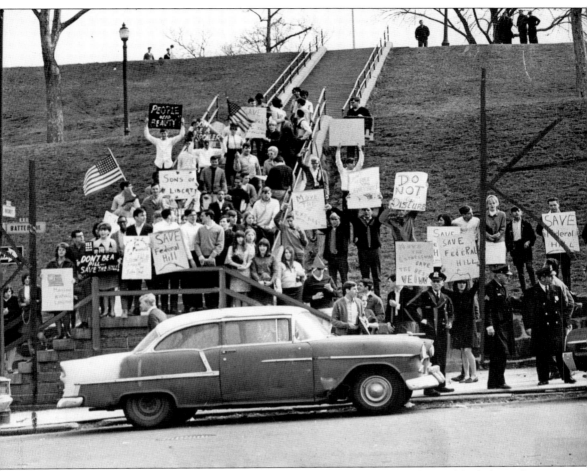

In March 1967, students from Southern High School, which stood less than a block from the park, took to Federal Hill to protest the city's plan. They were hardly alone in letting their voices be heard. Several anti-highway groups sprang up throughout the city, including the Relocation Action Movement (RAM), the Movement Against Destruction (MAD), and the Southeast Council Against the Road (SCAR). But the one that may have put up the loudest and most effective protest was the Society for the Preservation of Federal Hill and Fells Point. Started in 1967, this group took the bold action of getting both communities listed in the National Register of Historic Places. Federal Hill officially became a National Register historic district in 1970. Federal Hill South would also become a National Register historic district in 2003. Sharp Leadenhall was listed as one of Baltimore city's historic districts in 2010—but it was nearly too late. The city's plans to pursue the highway plan in the 1960s and 1970s would have serious consequences for the neighborhood for years to come. (Courtesy of UMDL.)

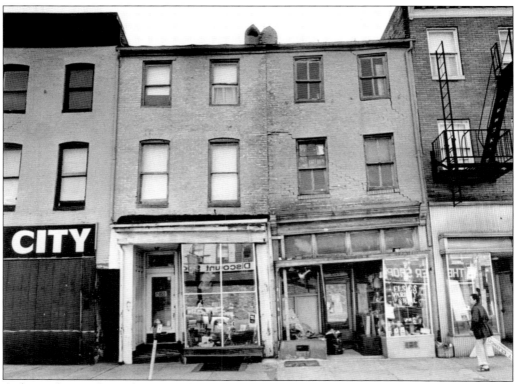

As key industries began leaving Baltimore in the 1960s and 1970s, the city started to show signs of decay. Federal Hill was no exception, as the photograph above of 1051 and 1053 Charles Street shows. In 1975, when both of these photos were taken, the community was looking ragged around the edges, in large part because the city had bought up many buildings in anticipation of the highway being built. For years, structures stood abandoned and fenced in, like the homes pictured below on Lee Street in Otterbein. Similar scenes existed on Montgomery, Hanover, Hill, Sharp, and Leadenhall Streets. (Both, courtesy of UMDL.)

The city buying up properties dealt a terrible blow to Sharp Leadenhall residents. Many, like the family in the photograph at right, simply received notices in the mail saying that their houses had been bought and were forced to move, accepting the price the city paid for their homes. Along with residences and neighbors, the community also lost stores and services. Below, Geneva Taylor waits on a young customer at her store, Taylor Grocery, in the 800 block of Sharp Street in 1972. One side of this block was targeted for demolition. In all, some 3,000 residents of Sharp Leadenhall and Otterbein were relocated, and the oldest African American neighborhood in the city shrank to nearly half its size. (Courtesy of UMDL.)

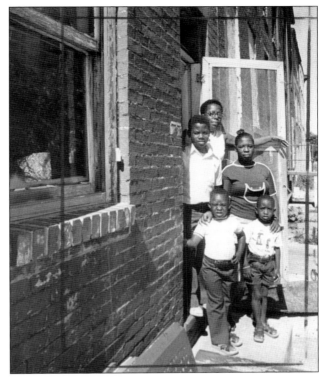

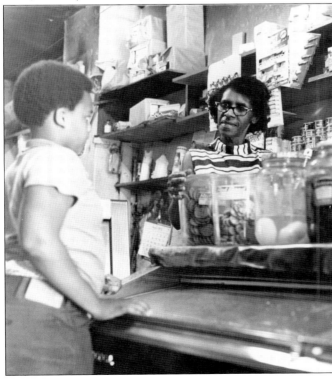

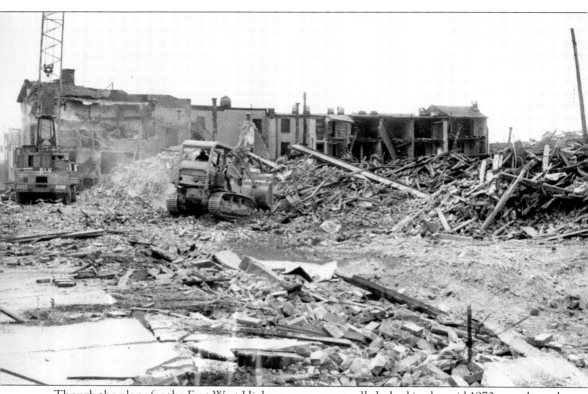

Though the plans for the East West Highway were eventually halted in the mid-1970s, one branch of the highway remained on the books. The I-395 spur was still slotted to run right down what was called the "Sharp Leadenhall corridor." As a result, several blocks of row houses, like these on Sharp Street, were bulldozed. In all, more than 350 houses were destroyed so that I-95 had an express link to downtown. As for the homes the city owned that stood empty, a radical and somewhat controversial plan was hatched. Mayor William Donald Schaefer is credited with the idea of selling the homes to willing buyers for $1 each. As most banks declined to finance the remodeling of these valueless homes, the city raised the money to provide loans to the new owners. To qualify, $1-homeowners had to agree to begin working on their renovations immediately and then live in the homes for at least 18 months. (Courtesy of UMDL.)

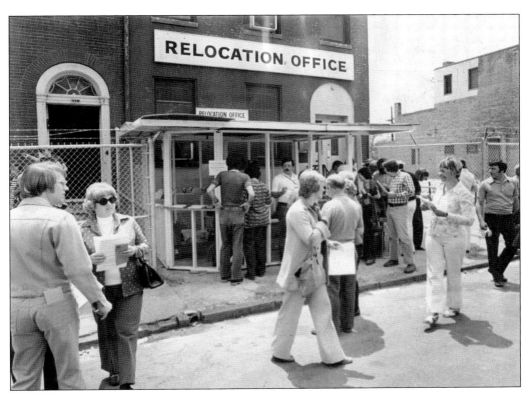

On a bright spring day in May 1975, hundreds of prospective buyers—many serious, some merely curious—arrived in Otterbein and began exploring the mostly dilapidated row houses. Most of the homes had been built in the early to mid-19th century. Armed with maps and information provided at the Relocation Office (above), they took off looking for that special diamond in the rough. They were free to enter the buildings at their own risk and get a good idea of how much work and money might be needed to salvage the fixer-upper of their dreams. At right, a group of potential buyers stops to discuss the highlights of what they have seen. (Both, courtesy of UMDL.)

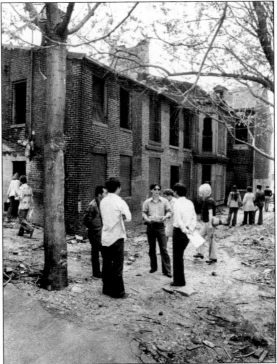

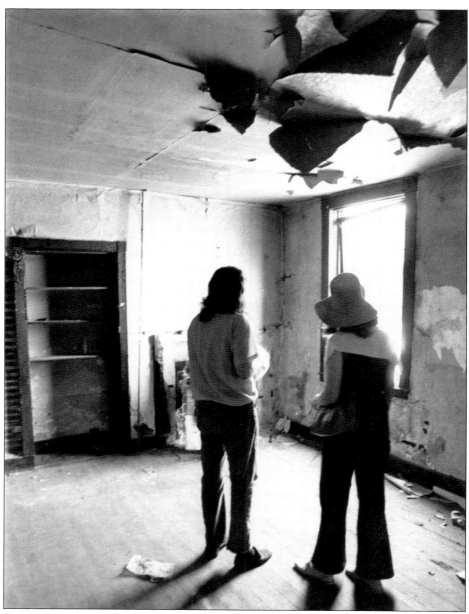

What prospective buyers discovered inside the vacant homes was often more daunting than what they saw outside. City loans topped out at $37,500 to get the homes back up to code. The 20-year loans were to be paid back with seven-percent interest. Apparently, a lot of people thought that was a very good deal—even after seeing homes like the one in the photograph above, and worse. In all, Mayor Schaefer's $1 house plan drew 788 applicants for the 113 row houses that the city put up for sale. The applications were reviewed by a committee to ensure that those desiring a house could really afford the conditions of the city loans, and 10 percent of the applicants were rejected through this process. Remaining individuals could apply for only one house. Houses with more than one applicant were put into a lottery, where Ping-Pong balls were drawn to determine the winner. (Courtesy of UMDL.)

In the Old Otterbein Church on the evening of July 31, 1975, Mayor William Donald Schaefer (right) plucked the first Ping-Pong ball out of the till. In the photograph at right, he hands it to Robert Embry, commissioner of the Baltimore City Department of Housing and Community Development, as George King (left) looks on. The owner of that winning ball was Joe DiPaulo, seen below with his girlfriend, Cookie. The beaming lottery winner could not wait to get started on the hard work ahead, renovating his new house, which stood at the corner of Sharp and Barre Streets. (Both, courtesy of UMDL.)

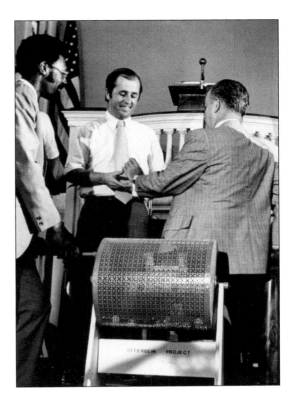

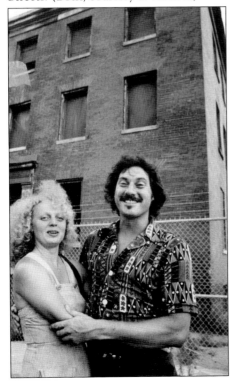

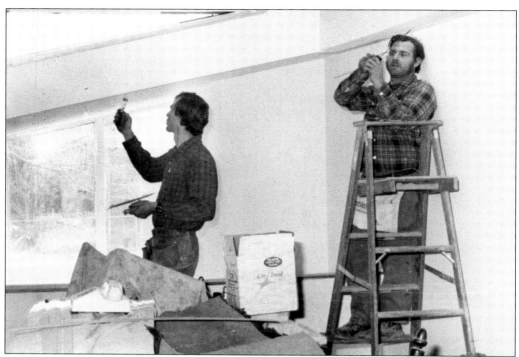

Now the real work began, and it certainly was not easy. Not only were there a lot of DIY jobs going on, as seen in the picture above, but there were also plenty of rules to follow and red tape to wade through. A private architectural firm was hired by the city to help homeowners with contract agreements, budgets, and floor plans. The houses were required to conform to a set of exterior design standards. An architectural review committee was made up of new homeowners who were elected by their neighbors. They were given the task of seeing that all exterior designs fell within the conformity plan. Below, a couple of contractors work on an Otterbein exterior, removing a very tired-looking roof. (Both, courtesy of UMDL.)

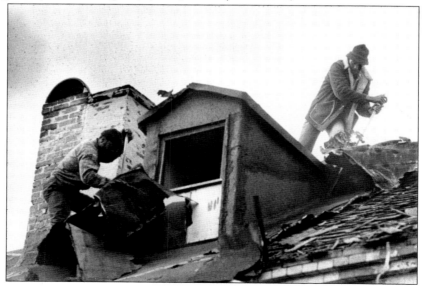

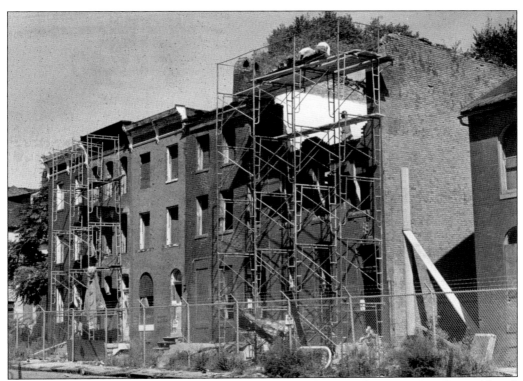

Homes were supposed to be habitable in six months, but these row houses on Lee Street (above) had seen little or no improvement in a year. There was a 20-percent dropout rate in year one of the program, and the newly available homes were reoffered to those who had previously applied for the same properties in 1975. Interest in the project continued, and the city was still receiving new inquiries about getting in on the $1 houses. In February 1976, the city had 10 houses that buyers had abandoned and for which there had been no other applications. These homes were offered to the nearly 700 applicants who had not received a house previously. Homeowners like this unidentified man (below) continued to make improvements and Otterbein slowly began to see signs of new life. (Both, courtesy of UMDL.)

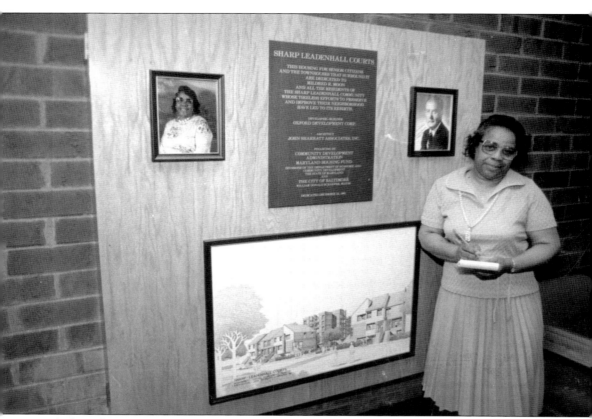

As homebuyers in Otterbein sparked a restoration boom, a hero emerged in Sharp Leadenhall. Mildred Rae Moon, a soft-spoken, religious wife and mother, was working as a seamstress in 1966 when a man came to her Hill Street home and told her she would have to move. The city was buying the house, and the highway was coming through. Moon was outraged and by 1967 had become a full-time activist, devoting all of her energy to fighting the highway. Her determined but respectful manner won her friends in city hall, and before long she was calling the mayor directly by phone. Though Mildred could not stop the razing of homes in her neighborhood, including her own, she persuaded city hall to devote $2 million to its redevelopment. Sharp Leadenhall Courts, composed of 100 townhomes and a senior citizen center, was built with that money. In the photograph above, Moon stands next to a plaque in the senior citizen center that dedicates the complex to her. She passed away in 1992 at age 68. (Courtesy of JMJR.)

The photograph above shows Sharp Leadenhall Apartments, a living unit that still reminds many neighborhood residents of Mildred Moon. The Hamburg Street Bridge, which arches from Sharp Leadenhall past the Baltimore Ravens football stadium, was renamed in Moon's honor. At right, 517 South Sharp Street (seen here in 1984) is a once condemned house from the mid-19th century that was at the time for sale for more than $100,000. In roughly 10 years, the neighborhood had gone from a crumbling and neglected section of town to one of the most desired addresses in the city. Though controversial, the Otterbein Project, as it was known, has been called Baltimore's most successful urban renewal project ever. (Above, courtesy of AU; right, courtesy of UMDL.)

It is hard to believe that these quaint Lee Street row houses are the same as the forlorn fenced ones at the bottom of page 86. For many, Otterbein has been transformed into an ideal neighborhood. Just blocks from the Baltimore Orioles Camden Yards ballpark and the Baltimore Ravens M&T Bank Stadium, the area is also just steps from the excitement of the Inner Harbor or the restaurants and bars of Federal Hill's business district. Along with these homes from the 1800s, blocks of new row houses were built in Otterbein in the 1980s. Streets such as Hanover Street and Sharp Street that were once major thoroughfares into the downtown area have been modified to cut down or even eliminate traffic. Charming vest-pocket parks dot the community. The result is a pleasant, quiet, and picturesque retreat. Otterbein was declared a Baltimore City Historic District in 1983. Needless to say, houses are no longer available for $1. (Courtesy of AU.)

Six

LEARNING, FAITH, AND HEALING

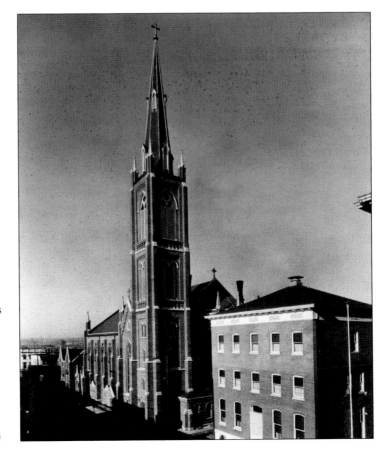

Though Federal Hill and the communities of South Baltimore were sustained by the industries and shops that did business around the harbor, the heart and soul of the neighborhoods were its institutions. As in other working-class communities throughout the United States, social activities centered on the numerous places of worship, like Holy Cross Church, seen here in 1932. (Courtesy of HCC.)

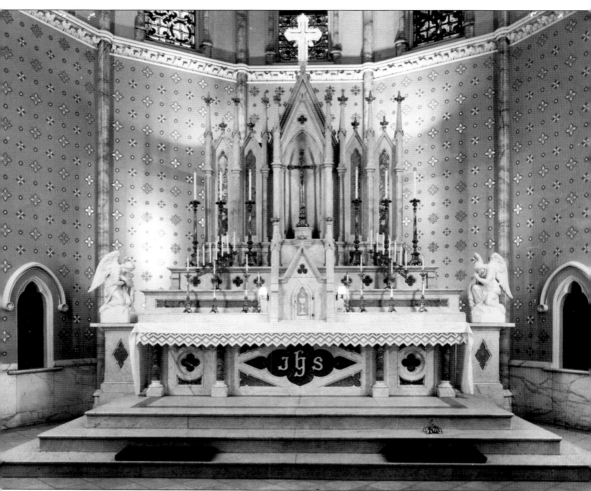

Holy Cross Parish in Federal Hill was the first Catholic church established in the South Baltimore area. The parish was founded in 1858 as a mission of St. Alphonsus Church for the 1,000 Catholics of German descent who lived in South Baltimore. The main church building was completed on West Street, near Light Street, in 1860; an addition was completed in 1885, including a towering, 200-foot steeple crowned with a copper cross. This photograph of the church's beautiful altar was taken in 1950. In 1980, powerful spring storms caused one of the four 1,000-pound steeple ornaments to fall through the church roof and damage the sacristy. Despite this setback, the exterior and interior of Holy Cross have been restored to reflect its original beauty. All of Holy Cross's original stained-glass windows have been restored, and the magnificent interior was cleaned and painted to reflect the vibrant color that existed in the original building. (Courtesy of HCC.)

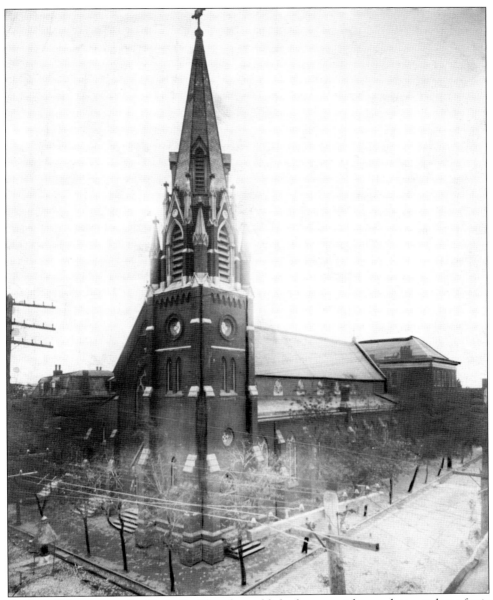

In the late 19th century, the Catholic Church established new parishes and new orders of priests and nuns to serve the German and Irish communities separately, even if they lived in the same neighborhood. St. Mary Star of the Sea Church, on the corner of Riverside and Gittings Street, was built in 1871 to serve South Baltimore's Irish community. The church was constructed with the assistance of the parishioners, who came in the evenings, after work, to dig out the building's foundation. Bricklayers, carpenters, and general laborers were then hired to erect the church. Most of the original interior furnishings (including the marble flooring) came from Europe. A blue beacon was installed in the church tower, which was lit to welcome home returning Irish sailors. In the 1960s, many of the original European furnishings were damaged or removed during a renovation. Luckily, many items, including the original altar, were recovered and reinstalled as part of a major restoration project that began in 2002. (Courtesy of UMDL.)

St. Mary Star of the Sea school began in 1877. In 1914, a new school building (seen here) was constructed at Battery and Gittings Streets, staffed by the Sisters of St. Joseph. In 1972, the school merged with the Holy Cross and Our Lady of Good Counsel schools as the South Baltimore Area Community School. In 1982, it was renamed the Catholic Community School of South Baltimore. (Courtesy of AU.)

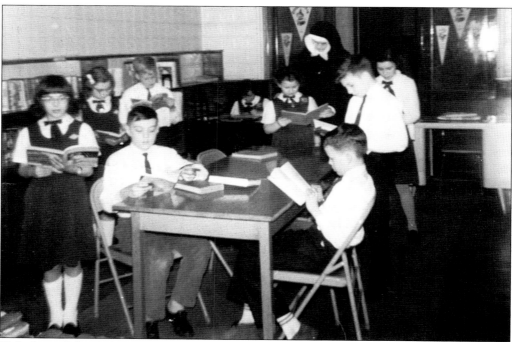

Holy Cross School, the first Catholic school on Federal Hill, opened in 1855. In 1857, it moved to new, larger quarters on West Street. For nearly 125 years, neighborhood children, like those pictured here, studied within its walls. When the community could no longer support three parochial schools in 1972, Holy Cross was shut down. The old school building was later converted to residential apartments. (Courtesy of HCC.)

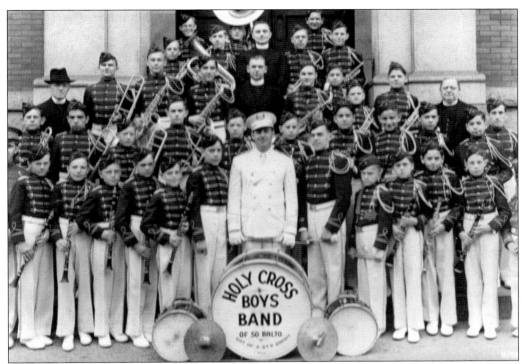

The Holy Cross Boys Band (above) was formed in 1933 when a band director was hired to teach the boys to play instruments such as clarinet, trombone, saxophone, tuba, and bass drum. The band played at school affairs and marched in parade formation throughout the neighborhood, sometimes even across the Hanover Street Bridge while leading baseball players to Swan Park's sandlot field for the start of the baseball season. Unfortunately, the band's glory days were brief. The program was discontinued in 1939, but this picture was cherished by band members through the years and aroused fond memories of childhood days in South Baltimore. One of the band's biggest fans was the pastor, Rev. Leo L. Otterbein, seen at right with some of the children of the parish during the celebration of his 50th year in the priesthood. (Both, courtesy of HCC.)

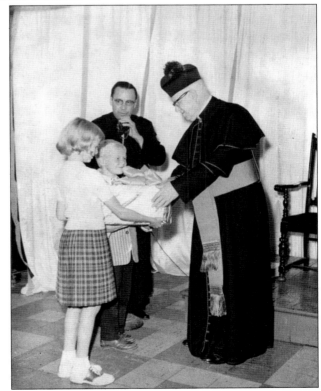

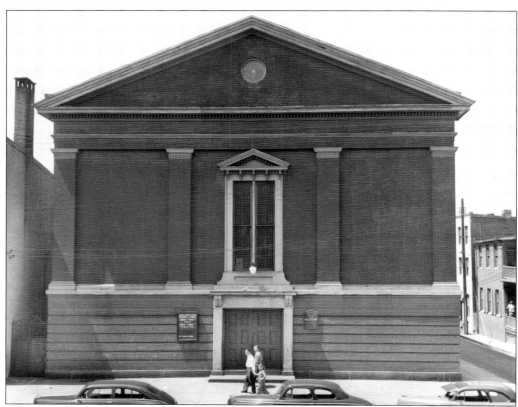

There were many Methodist churches and denominations by the mid-1800s in Baltimore. The picture above, taken on May 3, 1951, is of the South Baltimore Station Methodist Church at 820 William Street, on the corner of Churchill Street. The original building went up in approximately 1851 and typifies the Classical Revival architectural design of the period, with its simple and dignified facade. After the church closed, the building was converted for residential use, as seen below. Now, it contains luxury condominiums with added windows and terraces, as well as a parking garage for residents. (Above, courtesy of UMDL; below, courtesy of AU.)

The Ebenezer African Methodist Episcopal Church on 20 West Montgomery Street is listed in the National Register of Historic Places. The congregation was incorporated in 1848 and housed in a brick building that it quickly outgrew. On July 5, 1865, the foundation was laid for a larger church and parsonage to accommodate the growing congregation. The new building was dedicated on April 5, 1868. The photograph below, taken in the 1980s, shows workers giving a face-lift to the building's brick facade. The City Commission for Historic and Architectural Preservation lists Ebenezer AME as the oldest standing church in Baltimore built and continuously occupied by the same congregation. Among the church's many distinctive features are pews and ceiling beams made of Georgia pine and a striking marble pulpit that dates to 1916. (Right, courtesy of UMDL; below, courtesy of AU.)

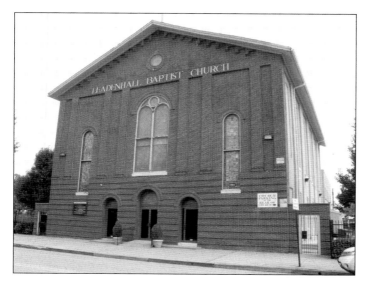

Founded in 1873, Leadenhall Baptist Church at 1021 Leadenhall Street is the second-oldest African American church in Baltimore, after Ebenezer AME. The buildings across the street from it were demolished for highway expansion and urban renewal in the 1970s. Fortunately, this beautiful building was spared, and Leadenhall Baptist Church is today one of the largest African American congregations in the city. (Courtesy of AU.)

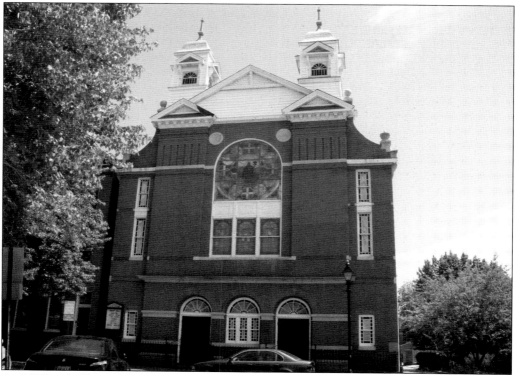

At 717 South Sharp Street is the Church of the Lord Jesus Christ. The church was built by a congregation of Methodists in 1889 on the right-hand side of the corner of Montgomery and Sharp Streets. The charming church building retains many of its original features such as the stained-glass windows and the vintage Belgian-block paving stones that line the two adjacent streets. (Courtesy of AU.)

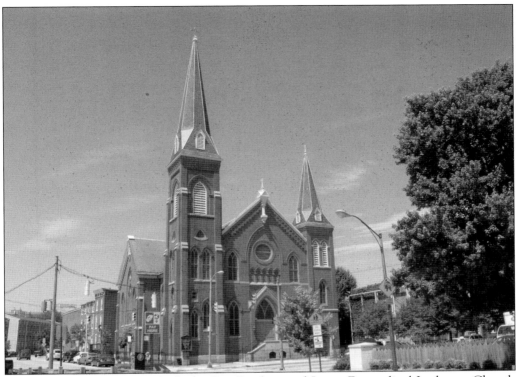

The majestic building in which the Sts. Stephen and James Evangelical Lutheran Church congregation worships was erected in 1850 by the Good Samaritan Congregation. Shortly thereafter, it became the Saint Stephen's German Evangelical Lutheran Church. The majestic redbrick church stands on the northwest corner of Hanover and Hamburg Streets, towering over the adjacent buildings. (Courtesy of AU.)

School House Mews at 821 Sharp Street is another example of the repurposing of historic buildings to accommodate modern use. The renovation of the 100-year-old building that once housed the elementary school known as PS 123 was completed in June 1987. The charming building now houses ten 1,080-square-foot townhouse condominium units, each with two bedrooms, two and a half baths, and full basements. (Courtesy of AU.)

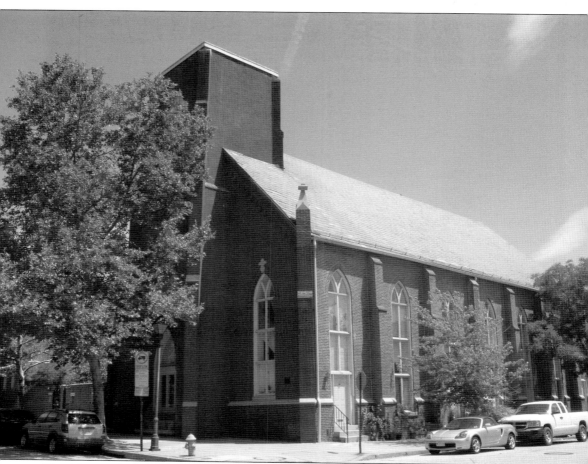

The Martini Lutheran Church was an offshoot of Baltimore's original Confessional Lutheran congregation, organized in 1835. The growing church later disbanded to form three neighborhood congregations, with the one in South Baltimore building its own church in 1868 at Sharp and Henrietta Streets. Through the years, many of the original members of the German congregation moved away from the neighborhood but returned to the church to worship. Like many other institutions in the old Sharp Leadenhall area, the building was condemned by the city in the mid-1970s as part of the proposed highway expansion. The congregation had nearly given up relocating in South Baltimore when, with the help of Mayor William Donald Schaefer, a new site was found just two blocks from the old one. There, a new building and hall were erected and dedicated on November 6, 1977. Ironically, the old church was not demolished. Instead, it was converted into the Bell Tower Commons, housing nine highly coveted 1,200-square-foot townhouse condominium units. (Courtesy of AU.)

In July 1846, a badly damaged merchant ship called the *William Penn* that sat moored to the old pier at Light and Lee Streets embarked in a new incarnation. It was converted into a place of worship for sailors visiting the Port of Baltimore, as seen on the plaque at right. Organizers fitted it with a pulpit and benches, built a roof over the deck, and appointed a minister. During services, as many as 600 sailors would overflow the benches. However, this picturesque nautical church was short-lived, condemned by the city just six years later. Undaunted, the congregation eventually settled into the small structure shown above at Cross Street, near Covington, in 1873. A congregation still worships there under the name Sailors Union Bethel Methodist Church. (Both, courtesy of AU.)

Another old Federal Hill church is the Lee Street Baptist Church. This congregation first met in 1855 at a South Baltimore stable on Hill Street, where worshipers would gather for bible studies and Sunday school. In 1885, the congregation established itself as the Lee Street Baptist Church. In 1912, the church moved to its current location at 113 Warren Avenue and changed its name to the Lee Street Memorial Baptist Church. Many of the original features of the Lee Street Church, such as the wooden pews and the pipe organ, were brought over to the Warren Street building. In recent years, sparked by community outreach to younger neighborhood residents, the church has become reinvigorated by young musicians and artists, exemplified by its Warren Fine Arts Academy of Music that offers private and group music lessons for violin, viola, cello, and piano. The church also hosts free monthly recitals that feature talented young artists, often from Baltimore's renowned Peabody Institute. (Courtesy of AU.)

The cornerstone for the Light Street Presbyterian Church (right) was laid on November 24, 1854. Located at 809 Light Street, the church features an Adam-Stein pipe organ. Only 20 were ever built, and only six remain. Light Street Presbyterian runs an active soup kitchen for the homeless and created Light Street Housing Corporation to rehab row houses for local low-income residents. The Church of the Advent (below) is an Episcopal church that was established in 1868. Like Light Street Presbyterian, it claims a diverse and welcoming congregation. Many longtime residents recall the high school dances held there in the 1970s. It is located at 1301 South Charles Street. (Both, courtesy of AU.)

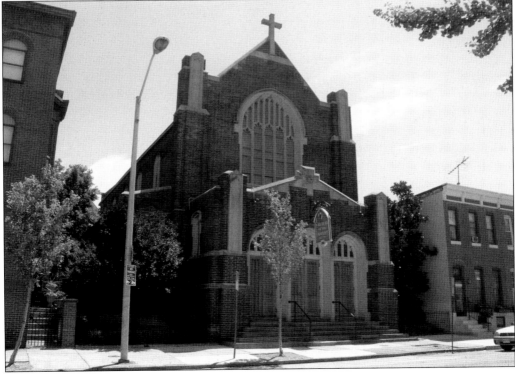

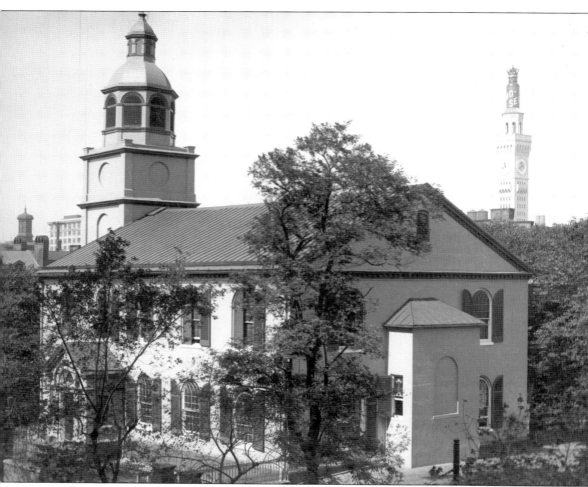

Across Sharp Street on the northeast corner of Conway is the oldest church standing in Baltimore. The Old Otterbein Church is built entirely of bricks used as ballast discarded by ships in the Inner Harbor. All of the nails used in its construction were made by hand. It opened its doors in 1785 with Phillip William Otterbein installed as its first pastor. Otterbein and Martin Boehm helped found the United Brethren in Christ in 1800, and Otterbein's church became the cradle of the new denomination. A parsonage was built near the church in 1811, and in 1827 the congregation opened the first German Sunday school in Baltimore. Phillip Otterbein died in 1813 and was buried in the churchyard. The church was a very important part of the history of the German community in Baltimore. It originally held services only in German, but English services were added by 1896. It is also said that when immigrant ships would arrive in Baltimore Harbor, the church would ring its bells to welcome the new arrivals. (Courtesy of EPFL.)

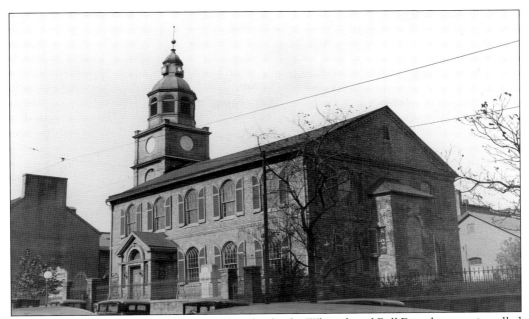

The Old Otterbein Church's bells, cast in London by the Whitechapel Bell Foundry, were installed in 1789. They have been rung for nearly every important event in American history since the end of the Revolutionary War. In 1969, the church was listed in the National Register of Historic Places. This photograph shows the two-story brick Georgian structure in 1932. (Courtesy of EPFL.)

The church also contains one of the eight remaining organs built by Henry Nieman. The organs were made in Baltimore and are known for their clarity and powerful sound. The interior of the church has been remodeled several times during the course of its more than 225 years of use, but the colonial sanctuary retains its elegant and simple charm, as seen in this photograph taken in 1936. (Courtesy of EPFL.)

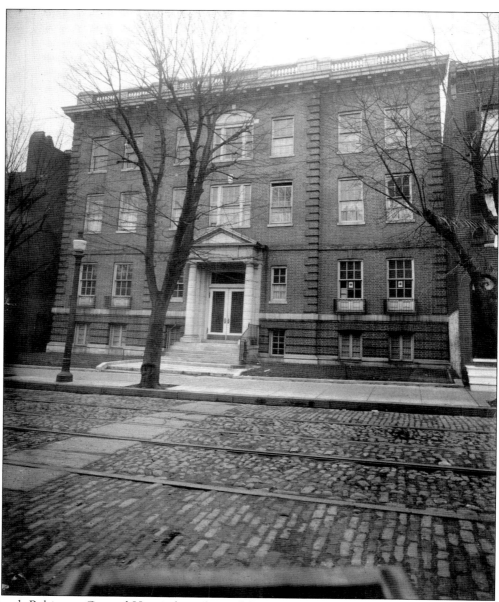

South Baltimore General Hospital was located for years at 1213 Light Street. Originally named the South Baltimore Eye, Ear, Nose and Throat Hospital, the hospital was established by Dr. Harry Peterman in 1901. It opened in a three-story house at 1017 Light Street. In 1903, the clinic moved to the 1200 block of Light Street, where it expanded in order to better serve the community's needs. By 1918, it became a general hospital with an "accident room," providing emergency care for "sudden injuries," many of which resulted from workplace accidents at nearby industries such as the Bethlehem shipyard. Southern Baltimore General Hospital enjoyed the support of the community. The records of the Kiwanis Club of Baltimore show that in 1939 it provided for the development of a baby clinic and a baby ward and helped raise $75,000 for other additions to the hospital. In 1940, more funds were donated to enlarge and refit the children's ward. (Courtesy of UMDL.)

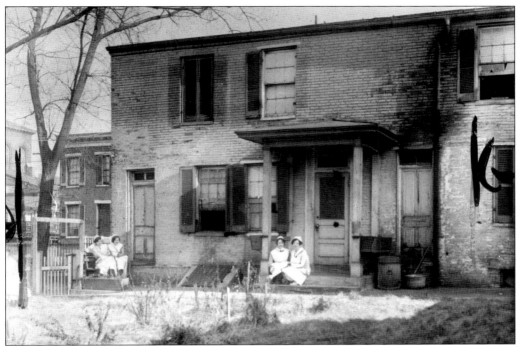

In the first part of the 20th century, most nurses were trained in local hospitals rather than at nursing programs in colleges or universities. In the fall of 1918, South Baltimore Hospital opened a School of Nursing. Nurses and student nurses worked very long shifts and frequently lived in group facilities. Above, nurses from South Baltimore General Hospital sit outside of the nurses' residence, probably on Charles Street, in 1927. During the Depression, there was a shortage of hospital nurses and student nurses in the United States. In 1930, there were 80,000 student nurses; in 1935, there were 67,533. The photograph below, taken in 1935, shows nurses working in a Southern Baltimore General Hospital operating room. (Above, courtesy of UMDL; below, courtesy of BMI.)

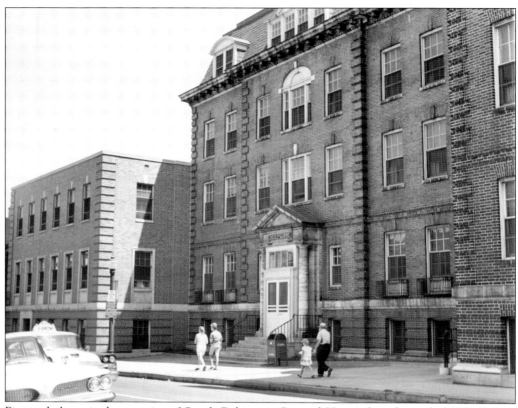

Pictured above is the exterior of South Baltimore General Hospital in the early 1960s. Below, doctors in the emergency room work on a young boy who was the sole survivor of an automobile accident on Ritchie Highway. During the 1960s, the hospital outgrew its location on Light Street. With no room to expand in its current location, it purchased 12 acres from Broening Park, formerly the site of the Maryland Yacht Club. Construction of the present facility, which is now called Harbor Hospital, began in 1967. The old building on Light Street still stands today and houses apartment residences. (Both, courtesy of UMDL.)

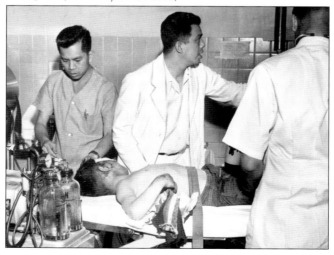

Southern Junior High School was built in 1919 at the southeast corner of Warren Avenue and William Street. In 1929, the community had grown to the extent that a new and bigger senior high school was needed, and Southern High School (above) opened its doors just east of the old junior high school in 1925. It was at the center of teen life in Federal Hill and its surrounding neighborhoods for the better part of the 20th century. The building was constructed of brick on a 2.45-acre site, containing an auditorium (below), three gymnasiums, a 500-person capacity cafeteria, a library, six shops, six home education rooms, one laboratory, and 44 classrooms. (Above, courtesy of EFPL; below, courtesy of UMDL.)

These photographs show Southern High School students in 1953: boys mixing it up in home economics (left), and girls drilling away in shop class (below). By 1955, Southern High School's 1,800 students required even more space. Mayor Thomas D'Alesandro Jr. broke ground on an expansion project designed to accommodate an additional 600 students. The $2 million expansion added eight more regular classrooms, five new art rooms, eight business education classrooms, three music rooms, and three shops for machine, print, and auto mechanic instruction, some of which were quite high-tech in their day. (Both, courtesy of UMDL.)

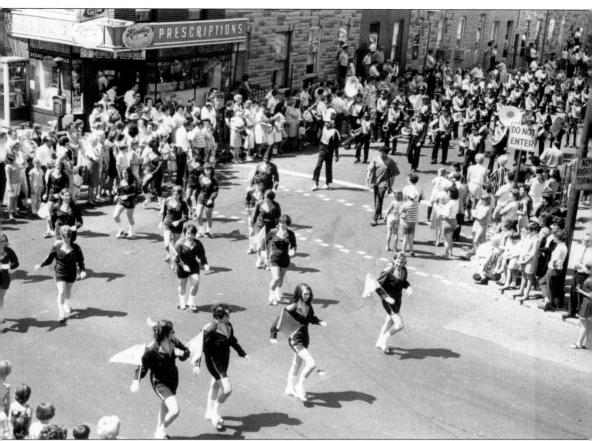

Extracurricular activities, such as marching band, boosted school spirit at Southern. This late-1960s march through Federal Hill's streets was well attended by the community. There were no athletic fields on school grounds, so the teams would often practice at Carroll Park, a 40-minute walk from the school. In spite of this, the Southern Bulldogs produced many fine teams over the years. The school's most celebrated alumnus is probably Al Kaline, a hall-of-fame outfielder for the Detroit Tigers. He was drafted right out of Southern High, where his classmates remember him as a quiet student who lit up the playing field with his exploits against rival teams. According to school lore, Kaline was rarely seen without his maroon Southern letter jacket. At his 50th class reunion, Kaline addressed the crowd and talked about his memories of Southern, which included meeting his future wife in the school's lunchroom. (Courtesy of UMDL.)

In 1872, the General Assembly of Maryland mandated separate but equal white and black schools. But on May 17, 1954, the United States Supreme Court decision on Brown v. Board of Education ruled that state laws establishing separate public schools for black and white students were unconstitutional. That fall, 34 black students were scheduled to attend classes with 1,758 whites at Southern High. Weeks went by without a major incident until October 1, 1954, when segregationists rallied a mob of 800 people around the school. In the photograph above, taken that day, some students cut class to join the protesters while others watch from the school's windows. Below, Southern High students gather later that day to discuss events. Most students accepted and even welcomed the new students, and the integration of Southern high was a success. (Both, courtesy of UMDL.)

By 1976, the school had again outgrown its capacity. Baltimore City Public School officials decided to build a new, larger Southern Senior High School in the 1100 block of Covington Street. As is often the case with buildings in Federal Hill, the old Southern High School was not completely demolished. The structure was renovated and reopened in September 1981 as a luxury apartment complex. (Courtesy of UMDL.)

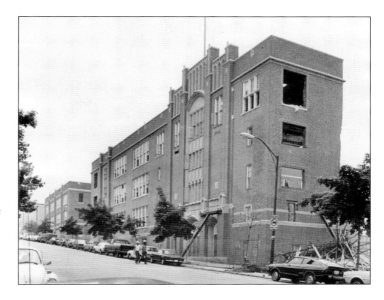

Southern High School was transformed into Digital Harbor High School in 2002. The school underwent a multimillion-dollar renovation to become an innovative, technology-focused high school for computer studies. After the last official graduates of Southern High School received their diplomas in 2005, Digital Harbor High became a magnet school, drawing students from the entire city of Baltimore. (Courtesy of AU.)

The volunteer Watchmen No. 16 Fire Company, organized in 1840, was the first fire station in South Baltimore. Originally, the company was housed in a stable on York Street, but it subsequently moved to new quarters at 125 East Montgomery Street, pictured here as a converted private residence in 1982. The company ceased active service in 1859, after the city established a paid fire department. (Courtesy of UMDL.)

Federal Hill's current fire station on the corner of Light and Montgomery Streets is seen in this 1960 photograph. The station opened on Dec. 21, 1920, as the headquarters for Engine 2 and District Engineer 6. In operation nearly 100 years, the station provides fire services for Federal Hill, Locust Point, Mount Clare, Ridgley's Delight, Sharp Leadenhall, Union Square, the downtown business district, and the Inner Harbor. (Courtesy of BMI.)

Due in large part to citizens' and merchants' concerns about public safety, the city passed a law in 1784 establishing a paid peacekeeping force called the Watchmen. Although this arrangement functioned for a while, the city's growth and prosperity brought with it increased criminal activities, which sparked another cry for reform. To this end, the police department was restructured again in 1854, creating districts that still exist today. Federal Hill was in the Southern District; in 1896, a handsome brick-and-stone-faced Romanesque Revival building was erected at 28 Ostend Street to serve as its station. It was used as a police station until 1962 and is now the site of an adult learning center, as seen here. Though converted to a different use, the building retains the words "Southern District Police Station" over the center bay of the facade on Ostend Street. (Courtesy of AU.)

The Maryland Science Center began as the Maryland Academy of Sciences, the state's oldest scientific institution and one of the oldest such institutions in the country. Established in 1797, the academy was housed in several different buildings over the years, including the Enoch Pratt Library. In 1976, the academy found a new home on the Inner Harbor, across Key Highway from Federal Hill Park. Seen above is a picture of the ground-breaking ceremony. The completed science center pictured below features interactive exhibits, the state-of-the-art David Planetarium, and an IMAX theater. More than half a million people visit it each year. (Above, courtesy of UMDL; below, courtesy of AU.)

The mission of the Baltimore Museum of Industry (BMI) is to collect, preserve, and interpret the industrial and technological heritage of the Baltimore region for the public by presenting educational programs and exhibits that explore the stories of Maryland's industries and the people who created and worked in them. Founded in 1977 on the site of the old Platt & Company oyster cannery (above), the museum features exhibits on a wide range of manufacturing and industry. The BMI is also home to the *Baltimore* (below), built in 1906 and the oldest surviving steam tugboat. The *Baltimore* is registered as a national historic landmark. (Courtesy of AU.)

The Baltimore Museum of Industry's library contains over 5,000 volumes of rare and historic books. The manuscript collections cover all major industries in Baltimore, from canning and the cloth trades to violin-making and the steel industry. Its impressive photographic collection consists of more than 250,000 prints and negatives, including the Baltimore Gas and Electric Company Print and Negative Collection. A favorite stop for field trips, the educational programs offered by the museum provide an enriching context for students to engage with Baltimore's rich industrial history by becoming workers in a garment loft or in the Kids Cannery. This hands-on experience provides insight into what some of their ancestors might have been doing for a living in South Baltimore. For adults, BMI serves as host to some of the city's biggest charity events, balls, and even weddings. (Courtesy of AU.)

The one-of-a-kind American Visionary Art Museum is located on a 1.1-acre wonderland campus at 800 Key Highway. Three renovated historic industrial buildings house inspiring and fanciful works of art created by all kinds of people, including farmers, housewives, mechanics, retirees, the disabled, and the homeless, using materials ranging from carved roots to embroidered rags to toothpicks. Critically acclaimed as an "architectural jewel," the 35,000-square-foot main building combines a three-story historic industrial building with extensive new architecture to contain galleries filled with spirit, smiles, and wonder. The glittering Community Mosaic Wall, on the building's exterior, was created by hand by Baltimore students. (Pictures courtesy AU.)

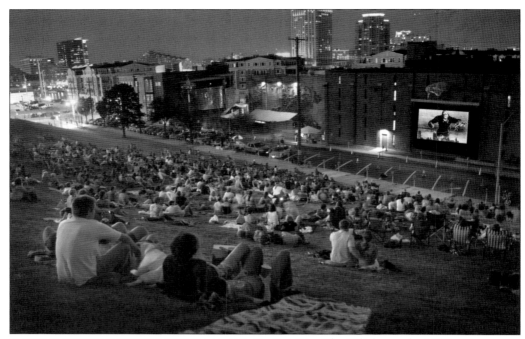

The "Flicks on the Hill" series at AVAM offers several free movies each summer. Seating at the Hughes Family Outdoor Theater consists of the natural amphitheater formed by Federal Hill, where as many as 1,000 people can view the 30-foot-wide screen held from above by the *Giant Golden Hand*. The spectacular view from the hill helps create an amazing, family-friendly experience. (Courtesy of AVAM.)

AVAM's Jim Rouse Visionary Center opened in 2004, more than doubling the museum's exhibition space. A bird-themed entrance plaza (pictured) welcomes visitors into the building, featuring an eight-foot sculpture of an egg by Andrew Logan; a towering 40-foot steel *Phoenix* by visionary artist Dr. Evermor; and the whimsical *Birds' Nest Balcony* by David Hess. (Courtesy of AVAM.)

Above, a determined amphibian makes its way down Riverside Avenue during the 2007 running of AVAM's annual Kinetic Sculpture Race. The tradition began in 1999, and features fanciful, handmade, human-powered moving sculptures. The racers, called "kinetinauts," pilot pink poodles, giant armadillos, gingerbread houses, and other unique vehicles over a 15-mile route that begins at the museum. Below, a much faster vehicle, piloted by Indy-car driver Ed Carpenter, takes the hairpin turn on Light Street in front of the Maryland Science Center during the inaugural run of the Baltimore Grand Prix in 2011. Cars hitting the straightaways at 140 miles per hour burn through the streets of downtown Baltimore over Labor Day weekend, passing through the borders of Federal Hill and Otterbein along the way. (Both, courtesy of AU.)

DISCOVER THOUSANDS OF LOCAL HISTORY BOOKS FEATURING MILLIONS OF VINTAGE IMAGES

Arcadia Publishing, the leading local history publisher in the United States, is committed to making history accessible and meaningful through publishing books that celebrate and preserve the heritage of America's people and places.

Find more books like this at
www.arcadiapublishing.com

Search for your hometown history, your old stomping grounds, and even your favorite sports team.

Consistent with our mission to preserve history on a local level, this book was printed in South Carolina on American-made paper and manufactured entirely in the United States. Products carrying the accredited Forest Stewardship Council (FSC) label are printed on 100 percent FSC-certified paper.